Famous Scottish Faces Caricatured

To the memory of our friend Derek Gibson, 1943-2003.

Mercat Press Edinburgh
www.mercatpress.com

Copyright © Scottish Cartoon Art Studio, 2006
www.scottishcartoons.com

Fizzers Volume 1

First published in 2006 by
Mercat Press Ltd.
10 Coates Crescent
Edinburgh EH3 7AL
www.mercatpress.com

Design
Caroline Taylor

Cover Design
Danny Cardle

ISBN 10: 1-84183-094-1
ISBN 13: 978-1-84183-094-0
Printed in Great Britain by Bell & Bain Ltd.

CONTENTS

Fizzer n. 1. Scots slang for face.

ACKNOWLEDGEMENTS

The Scottish Cartoon Art Studio would like to acknowledge the support of the following people who helped make this book a reality:

Brian Cox and Vanessa Green for the wonderful Introduction; Danny Cardle for his elegant cover design; Crawford Little at BBC Scotland for providing masses of archive photographs; Rikki and Kate Fulton, whose generosity with personal photographs helped us at the very beginning of this journey; James Cosmo, Una McLean, Annabel Meredith, Maurice Roëves and Tony Roper who all gave of their time and helped with hard-to-find photos; Jim Dee for colour on pages 5 and 72; the staff at Equity's Glasgow Office; David Miller and all at Miller's Creativity Shop; Isla O'Hara at IWC Media; Judy Vickers at the *Edinburgh Evening News* for use of the quote on page 22; everyone involved in the Salon International de la Caricature, du Dessin de Presse et d'Humour, Saint-Just-le-Martel, France, for their inspirational example and kindnesses; James Holloway and his staff at the Scottish National Portrait Gallery for giving *Fizzers* a home off the page; the Prince's Scottish Youth Business Trust and the East End Partnership, without whom there would be no Studio; our new friends at Mercat Press—Seán, Tom, Caroline and Vikki—here's to Vol.2!; and most of all, the long-suffering ladies in our lives—Margaret, Yasmin, Carey, Maria and Irene—who have often had to accept that their men were too busy working on giant noses, knotted eyebrows and wonky teeth to attend to other duties.

FOREWORD FROM BRIAN COX

As I get older I become more and more photophobic. Basically I can't stand the sight of myself in photographs and sometimes it actually affects me watching my own work in the cinema. Up there on the screen in huge image I always feel like the Elephant Man and it's a particularly unpleasant feeling. So being asked to write an Introduction to a book of Scots caricatures is almost like addressing the very essence of my phobia, but ironically the thing about caricatures—and certainly my caricature—is it kind of captures something that is quintessential. In some weird way it presents your character in a more reassuring way because fundamentally you become the vision of the caricaturist and it's curiously more flattering because you say: "Oh, that's how they see me. How interesting. Basically I'm very dull." Or, "What an interesting face!"; or "Why such dark eyebrows?"; or "I thought the dimple in my chin was a wee bit bigger!" So what happens is that your image, unlike the photographic image that betrays you, is only a matter of opinion. And there's something very comforting about this.

I'm delighted to be part of this collection and delighted in particular to see those characters who are no longer with us, characters who meant a great deal to me in my life. Fulton Mackay (p.40) was a huge influence on me, both as an actor and as a man, and (John) Duncan MacRae (p.68) was one of the true great eccentrics.

During my first job at Dundee Rep I remember struggling up the staircase to get Mr MacRae an armchair so he would be comfortable as a visiting artist performing Molière's *The Miser*. As I struggled with this chair, which was bigger than I was, up three flights of stairs, I eventually squeezed into his dressing room. MacRae was eyeing me in a very curious way and as I finally left the chair in his narrow dressing room he said: "I don't really see why you bothered with that. I am just as happy on a stool or preferably standing! Anyway I appreciate your efforts."

I particularly remember one night on stage with MacRae who was astonishing as the Miser; he had these curious birdlike movements, like a kiwi crossed with an ostrich. I was playing a young servant—a silent role—who had to wear a very mucky apron, but on this particular night I had forgotten to put it on as I was also the Assistant Stage Manager and busy doing lots of other chores. MacRae launched into his speech about the disgusting, filthy state of my apron, which he addressed to me from the far side of the stage. After he finished the speech he noticed that I wasn't actually wearing it. He bounded across the stage, held me in a feather-light grip and with his great cadaverous beak he whispered in my ear: "You haven't got it on. You'd better go and get it." And with that admonishment I fled the stage.

I think the richness of these faces, particularly the ones from the past, are images that I have carried with me since I was a wee boy. Apart from MacRae and Mackay, Ali Sim, Russell Hunter, Jack Milroy and the great, lugubrious Rikki Fulton. What faces. A caricaturist's dream.

Brian Cox (p.17)

INTRODUCTION

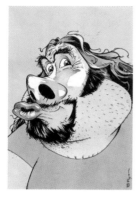

Scotland the brave? Perhaps... Until, that is, the big burly guy in the kilt is asked: "Would you like a caricature, sir?"

The look of quiet panic that spreads over his face remains, even after being told it's free. There seems no point in explaining further that it's all part of the evening's entertainment and intended as a gift from the Bride and Groom. Egged on by his wife, he reluctantly agrees and the first drawing of the night gets underway...

As caricaturists-for-hire, the six artists of the Scottish Cartoon Art Studio have paid their dues in this way, drawing hundreds, even thousands of faces over the last seven years. Some were world-famous, some totally unknown beyond their friends and family, but the work was always on request and to a tight deadline (often "in the next five minutes!"). Sitting down to put together a book of our own, we had the luxury of choosing whomever we wanted to draw, to deadlines we set, the way we wanted to do it. What freedom!

What a problem! Who do you choose when a world of faces presents itself? Inspired by the work of European—and most especially French—caricaturists like Jean-Claude Morchoisne, Patrice Ricord and Jean Mulatier, the Studio were determined to produce "pure" carica-tures. No editorial comments. No obvious props, gags, scenarios or satire. All humour derived from observation and exaggeration of the face. That took care of the "how".

But still there remained the question of "who"? Who to draw? Firstly, and most importantly by far, we wanted subjects that "gave good face": a face with character, a face that offered opportunities for humour. Sec-ondly, we focused on notable Scots, by birth or by association. Thirdly, there was the matter of reference. Caricaturists must work from life, or from good, clear photographs. They can't work from paintings; there's no point reinterpreting another artist's rendering of a face. A copy of a copy degrades the image.

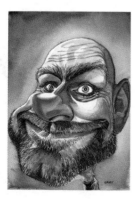

So, in purely practical terms, almost everyone who died before the turn of the twentieth century was ineligible. Out went the Wallaces, the Bonnie Prince Charlies, the Knoxes and Humes. And on that point,

this isn't an exercise in listing the "Greatest Ever Scots", either. Inclusion here doesn't indicate merit in terms of achievement. There are many generous, talented, gifted, heroic figures we'd never dream of caricaturing, simply because their work and their names are known, but their faces are not. The delight, the humour, the spark of a caricature depends on recognition. If the viewer doesn't know who it's meant to be in the first place, the most carefully observed, lovingly rendered caricature dies. Also, "notable" is different from "notorious". We're not interested in endorsing villains. No gangsters, murderers or crooks... Not in this volume, anyway.

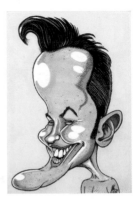

Even with all these self-imposed rules, the first poll among the artists threw up over four hundred names we were eager to draw. Entirely too many—that's several books' worth. We had to pause at some point, and let the presses roll on the first. Votes were taken, the least popular names eliminated. Still, names had to be dropped. Efforts were made to try and make the final selection as wide, varied, interesting and surprising as possible, but nevertheless, who's in and who's out will always be a compromise. We're scratching the surface, and don't pretend otherwise. Enjoy this book in the spirit it's intended: fresh, funny takes on some well-kent faces.

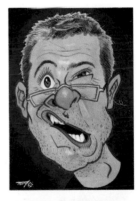

Drawing the big guy would be a lot easier if he'd just relax and smile. He seems confused by the growing laughter and the comments of the other guests as they watch the drawing come together. He's presented with the finished caricature and a beaming smile spreads across his fizzer. He can't hide his surprise: "That's brilliant, mate! I'll be framing this. I thought you were just going to take the mickey, but somehow you've really captured me..."

"Well, sir, Burns himself said it best—'O wad some Power the giftie gie us, To see oursels as ithers see us!'"

Top to Bottom:
Brian Flynn, Chris Sommerville,
Derek Gray,
Edd Travers, Terry Anderson,
Tommy Sommerville.

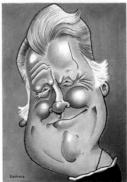

RIKKI FULTON

Born in Dennistoun, Glasgow in 1924, Rikki Fulton was a multi-talented and much-loved comedian and actor. He first made a big impression on television audiences in the role of Josie, playing against Jack Milroy's Francie (p.83). Later his Hogmanay show *Scotch and Wry*, with its collection of unforgettable characters such as Supercop and The Rev. IM Jolly, became a national institution during its 14 years on air. He received a lifetime achievement award from BAFTA in 1993. He died in 2004 having suffered from degenerative Alzheimer's disease.

❏

Rikki's caricature has a special place in the Studio's collective heart, as Tommy explains: "This was the first *Fizzers* piece, completed with input from Rikki and his wife Kate and finally viewed at their home in Glasgow. At the time, it was not public knowledge that Rikki was unwell, but Kate prepared me for the change that had come over him since his retirement from performing. On showing him the drawing, his face lit up with that huge, toothy grin of his and he cried out 'That's fantastic!' Then he turned to me with his equally familiar 'doon in the mooth' look and added, 'Who is it?' It wasn't until he gave me a further smile and a wink that I realised the caricature was a hit, and this was Rikki's way of making light of what he called 'Auld Timer's'."

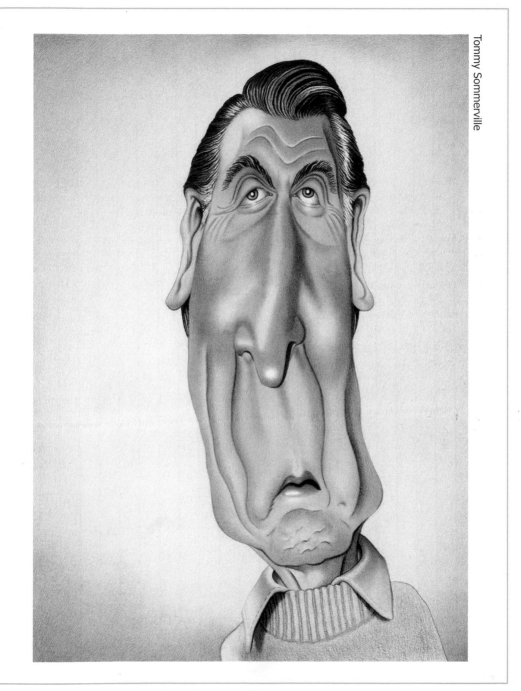

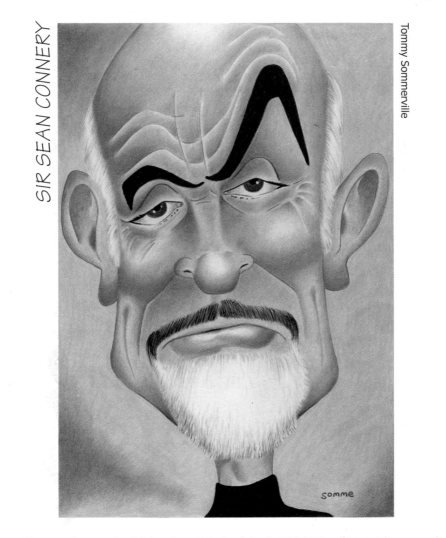

SIR SEAN CONNERY

Tommy Sommerville

somme

Born Thomas Connery in Edinburgh, 1930, this Oscar-winning actor is arguably the most famous living Scot, best known as the original cinematic James Bond. Creator Ian Fleming initially thought him "too unrefined" for the role, though he and Connery's fans alike came to consider the actor's performance in *Goldfinger* to be the definitive Bond. He has long advocated Scottish independence, and is a loyal supporter of the Scottish National Party. Connery received the Legion d'Honneur in 1991, Kennedy Center Honors from the United States in 1999 and a knighthood in 2000. He was presented with a Lifetime Achievement Award at the Berlin Film Festival in 2005. In the same year it was announced he would provide the voice of new Scottish animated character Sir Billi the Vet.

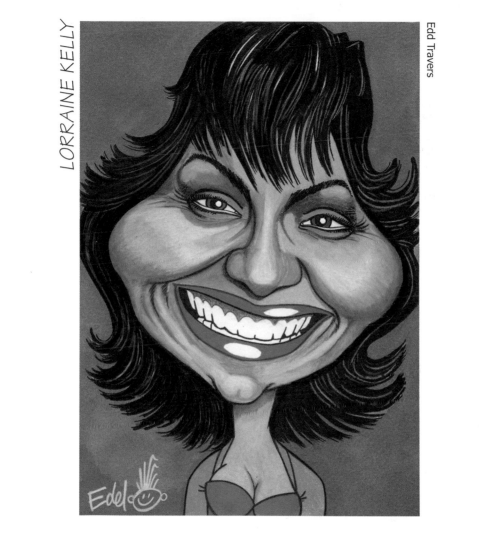

Edd Travers

LORRAINE KELLY

People across the United Kingdom invite Lorraine Kelly into their homes on a daily basis. The Glaswegian presenter, born 1959, joined the fledgling GMTV breakfast programme in 1993. Her sunny disposition and infectious good humour ensured her popularity. A cult figure, Lorraine is also a radio broadcaster, columnist, children's author and Rector of Dundee University.

❏

Edd: "Lorraine recently topped a poll of famous females men secretly fancy. (And I thought it was just me!) My preliminary sketches had been made from her morning TV appearances, but then I found an unofficial website, tastefully but enthusiastically devoted to the charm and 'physical attributes' of lovely Lorraine. The site's photos made a far better basis for caricature, so my thanks to all the like-minded Lorraine-lovers out there!"

Chris Sommerville

SIR ALEX FERGUSON

Born in Govan, Glasgow in 1941, Sir Alex has established himself as the most successful British football manager of all time. He worked in the Clyde shipyards until the age of 23 and later joined boyhood heroes Rangers in 1967 for a then-record £65,000. 1974 marked his retirement from the pitch and two years later he was appointed Aberdeen manager, turning them into a dynamic force in Scottish football in the early 80s, breaking the Old Firm's stranglehold on the Premier Division. He took over at Manchester United in 1986 and was responsible for fashioning the team that dominated the Premier League throughout the 90s.

DAVID COULTHARD

Brian Flynn

Born in Twynholm, Dumfries and Galloway in 1971, Coulthard was racing carts by the age of eight and racing for Formula Ford while still in his teens. With thirteen Grand Prix victories to his credit, he's one of the most successful drivers in the history of motor racing.

❏

Terry: "It's rare that a caricaturist can get away with using inorganic forms—straight lines rather than curves—without destroying a likeness. But Brian's interpretation of Coulthard's jaw isn't really very far from reality... You could use the man's head as a set-square!"

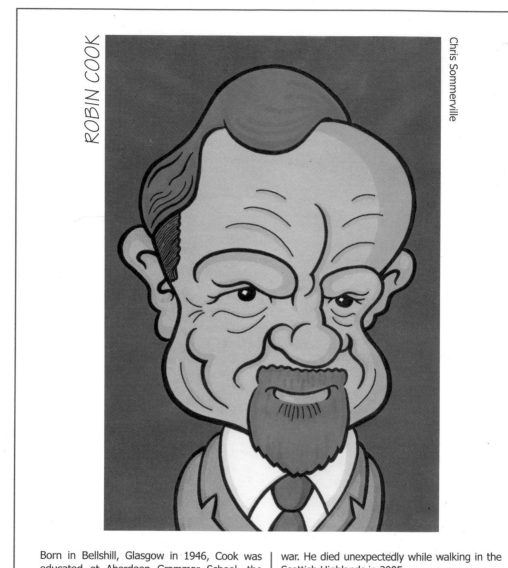

ROBIN COOK

Chris Sommerville

Born in Bellshill, Glasgow in 1946, Cook was educated at Aberdeen Grammar School, the Royal High School, Edinburgh and the University of Edinburgh. A lifelong Labour Party member and later MP, he became the party's Foreign Affairs Spokesman in 1994 and Foreign Secretary after the election victory in 1997. Cook received plaudits from all quarters for his principled resignation from the front benches over the Iraq war. He died unexpectedly while walking in the Scottish Highlands in 2005.

❏

Chris: "In life Cook was probably one of the most caricatured guys in the country. His was a great face with plenty of strong features. Having been tackled by so many others it was important that I came up with something different. I hope I've succeeded."

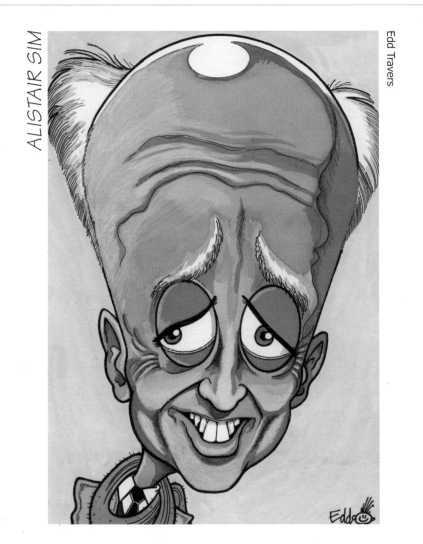

Stage and screen actor Alistair Sim (1900-1976) was born in Edinburgh. A highly educated and private man, he was a lecturer in Elocution, and later Rector, at the University of Edinburgh. Perhaps best remembered for his portrayal of Ebeneezer Scrooge in the 1951 film of Dickens' *A Christmas Carol* and as the redoubtable Miss Fritton in the St.Trinian's pictures, his rich voice, precise delivery and ability to alter his physicality to suit his roles would influence many other actors, including Sir Alec Guinness.

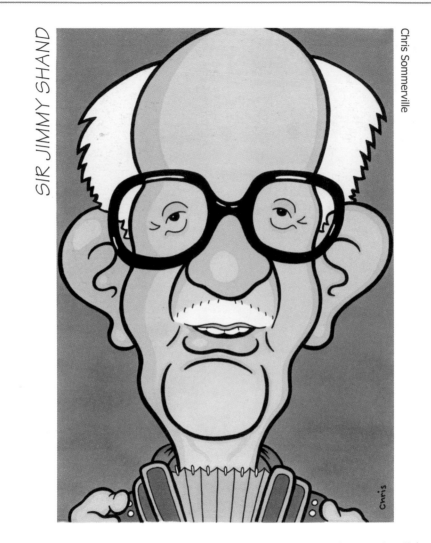

SIR JIMMY SHAND

Chris Sommerville

James Shand (1908-2000) came from the Fife coastal village of East Wemyss. He followed his father into the mines, but his time there ended with the General Strike of 1926. He began working in a music shop where he picked up the accordion that would become his signature instrument. Jimmy became one of Scotland's most popular country-dance bandleaders. After the Second World War, his popularity soared thanks to appearances on television shows such as *The White Heather Club* and hit albums throughout the 50s and 60s as well as international tours. Shand was knighted in 1999.

❑

Chris: "When I first started drawing Jimmy I didn't really know who he was. Then my Gran filled me in on all the man's great achievements. She saw the artwork when it was completed and asked for a print."

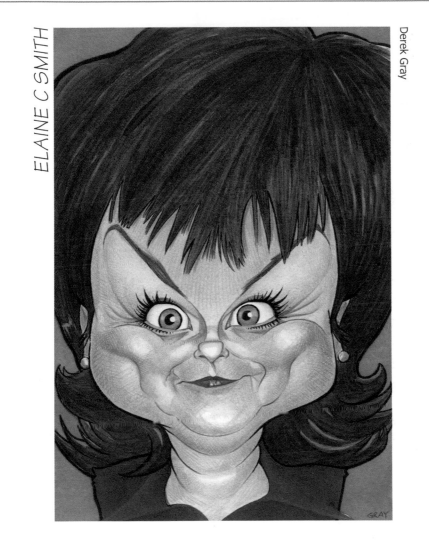

ELAINE C SMITH

Derek Gray

GRAY

Born in Baillieston in 1958 and raised in Mother-well, Elaine C Smith is an actor, comedian, writer and broadcaster. She is probably best known for playing Mary Doll, Rab C Nesbitt's long-suffering wife in the television show of the same name. Her appearances in Christmas pantos at the King's Theatre have become a Glasgow institution.

❑

Terry: "Arguably the best of Derek's collected here. The hair, skin and clothing are all rendered well, but it's the unabashed 'cartoonyness' of those eyes that give it real 'wow' factor."

Brian Flynn

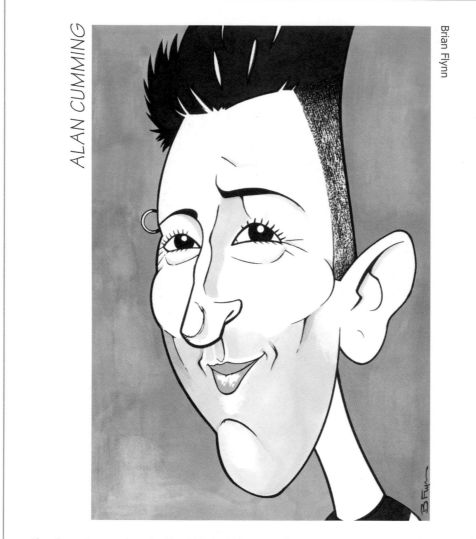

Alan Cumming was born in Aberfeldy in 1965. After spending his teens as a sub-editor for Dundee's DC Thomson, he met Forbes Masson at drama school and for many years the two were familiar as effete culture vultures Victor and Barry. Cumming is a versatile actor and comedian, whose CV features *Take the High Road* and *Sex and the City*, as well as a Tony Award-winning run in the most recent Broadway production of *Cabaret*.

Brian Flynn

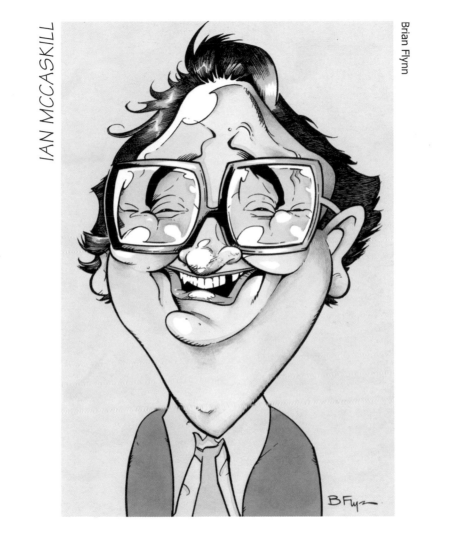

BFlyn

McCaskill studied science at the University of Glasgow, the city of his birth in 1938, until National Service took him to the RAF and thereafter the Meteorological Corps. He made his first appearance as a television weather forecaster in 1978, and became a fixture for the next two decades, memorably lampooned by *Spitting Image* among others for his breathless, excited delivery.

❏

Chris: "When you see a fantastic, lively caricature like this one of Ian McCaskill, you can't help yourself hearing that person's voice in your head or even doing a wee impression yourself. It's a compliment on the drawing's quality. When Brian turned this in, all I could say was 'Hulloooh!'"

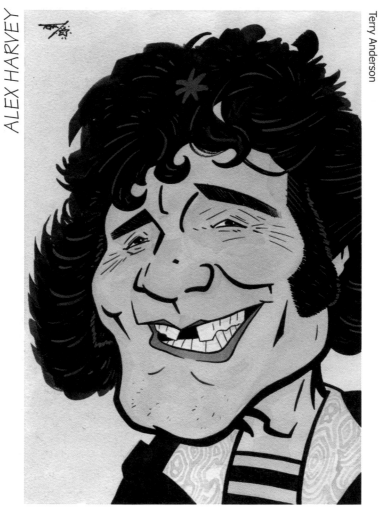

ALEX HARVEY

Terry Anderson

Glasgow's Alex Harvey (1935-1982) tried his hand at many professions, most famously lion-tamer, before winning a newspaper's *Pop Idol*-style search for young Scottish talent in 1956. Throughout the next two decades he enjoyed mixed success releasing records and fronting bands in diverse musical styles: skiffle, rhythm & blues, soul, folk and psychedelica. In 1972 he joined a prog rock group called Tear Gas, later renamed The Sensational Alex Harvey Band. Cult status, two hit singles and sell-out international gigs followed before a heart attack felled Alex while on tour in Belgium.

❑

Tommy: "This is a real favourite of mine, as I'm from the generation that saw Alex Harvey and listened to his music. He was a real character and a true Scottish rock legend. Terry has managed to capture his edginess spot-on."

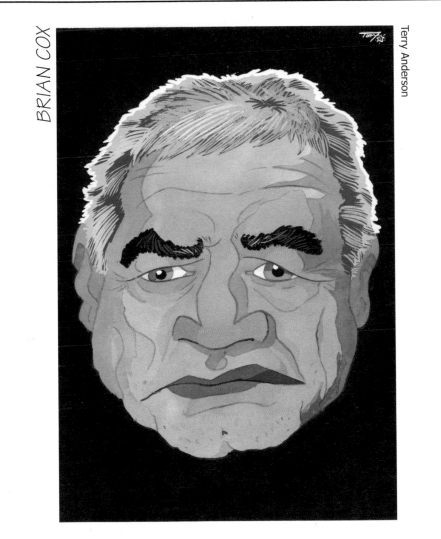

BRIAN COX

Terry Anderson

Born in Dundee in 1946, Brian Cox is an Emmy and Olivier award-winning stalwart of stage and television acting. In the past decade he has become increasingly conspicuous in major Hollywood productions, first making an impression as the original Dr Hannibal "The Cannibal" Lektor in *Manhunter.* He continued in a villainous vein through roles in *The Long Kiss Goodnight,* *X-Men 2, Troy* and the Jason Bourne series.

❑

Terry: "There's a strong resemblance to Marlon Brando in Brian's face. Indeed, I rejected my own first sketch because it looked too much like both men, and I risked confusing the viewer."

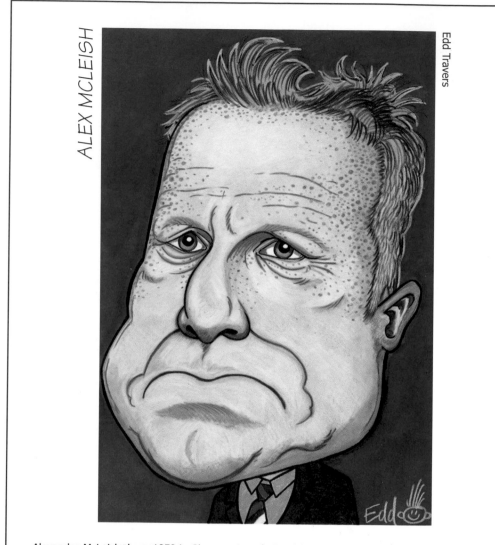

ALEX MCLEISH

Edd Travers

Edd

Alexander McLeish, born 1959 in Glasgow, is a figure familiar to any fan of Scottish football. A member of the Scotland Hall of Fame and holder of 77 international caps, he played for Aberdeen in the 70s, under the management of Sir Alex Ferguson (p.8). As manager of Motherwell in the 90s he aggressively pursued Walter Smith's Rangers (p.25) to the top of the SPL. Then, "Big Eck" took charge at Ibrox himself, and his tenure there was notable for dizzying highs (winning the treble in the 2002/03 season) and lows (nine consecutive domestic defeats in 2005).

TONY ROPER

Chris Sommerville

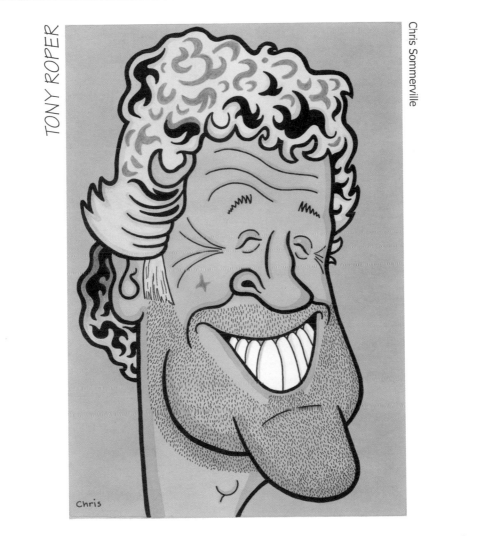

Chris

Glaswegian comedy actor Tony Roper was born in 1941 and is probably best remembered as Jamesie Cotter opposite Gregor Fisher's Rab C Nesbitt (p.52). However he is also a talented and prolific writer, his most notable credit being The Steamie, a popular play depicting four Glasgow housewives as they make use of a 1950s communal laundry one Hogmanay. Roper was a close friend of Rikki Fulton (pp.4-5), and collaborated with him as writer and performer on *Scotch and Wry* as well as two books of the Rev. IM Jolly's wit and wisdom.

❑

A portrait painter himself, Tony was suitably impressed with his caricature: "Thanks for improving on what nature did to me," he says with a smile.

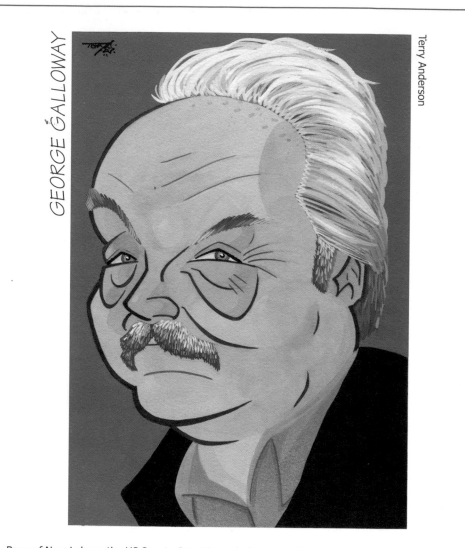

GEORGE GALLOWAY

Terry Anderson

Bane of New Labour, the US Senate Committee and newspaper editors everywhere, the ever-litigious and always-controversial "Gorgeous" George Galloway was born in Dundee in 1954. He was expelled from the Labour party in 2003, but returned to the House of Commons two years later as MP for the London constituency for Bethnal Green and Bow, having founded the anti-war Respect Party. In 2006 he made head-lines as a contestant on *Celebrity Big Brother*. Love him or loathe him, most political commentators concede he's nothing if not an entertaining and articulate parliamentarian.

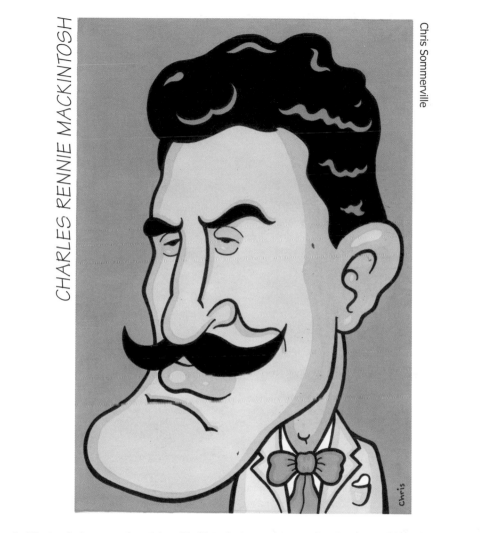

CHARLES RENNIE MACKINTOSH

Chris Sommerville

Architect, designer and painter Mackintosh (1868-1928) was born in Dennistoun, Glasgow. He began his career as an apprentice architect at the age of 16 and studied at the Glasgow School of Art, which would later headquarter itself in a building of his design. In 1893, he completed his first major project, the old *Glasgow Herald* building, now known as the Lighthouse, itself a museum of architecture and design with a permanent exhibition of his work. Mackintosh's name has become synonymous with his influential visual style, a unique blend of Art Nouveau and Scottish Celtic traditionalism. While best known in Glasgow for his buildings, his talents extended to interior design, furniture, print making and watercolour paintings.

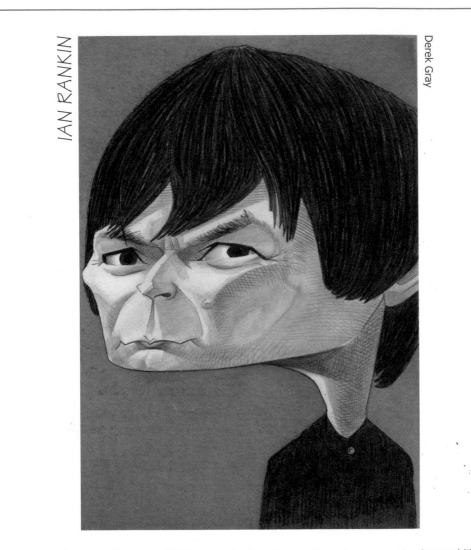

IAN RANKIN

Derek Gray

Author of the world-renowned Rebus novels, crime writer Ian Rankin was born in Fife in 1960. The first in the Rebus series was published in 1987 and his books have now been translated into 22 languages, as well as adapted for television.

❑

Says the author: "The caricature makes me look grumpier and more angular than real life, but in my photos I try to look mean and moody. Maybe this is what the artist is working from." Derek responds: "Ian saw this caricature shortly after completion and confessed that it didn't really 'grab' him. Yet it's one of my favourite pieces! Perhaps it is a case similar to not liking or recognising your own voice when it's played back at you..."

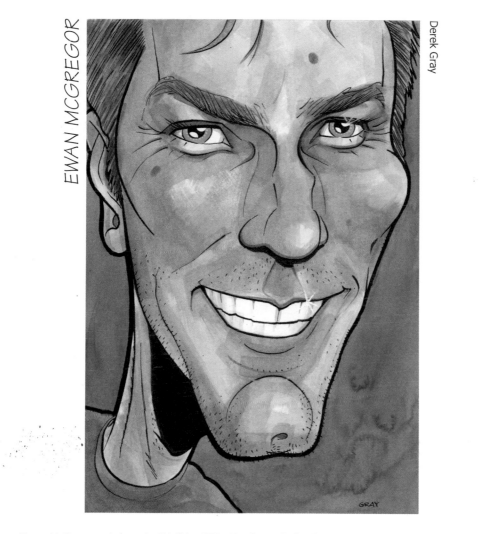

EWAN McGREGOR

Derek Gray

GRAY

Ewan McGregor was born in Crieff in 1971. He shot to fame as the anti-hero, Renton, in the cult film *Trainspotting* based on the novel by Irvine Welsh (p.73). He's recognisable to sci-fi fans the world over, having played the young Obi-Wan Kenobi in *Star Wars* Episodes I-III. Today he's heavily involved in charitable causes, most notably as a goodwill ambassador for UNICEF.

❏

This piece has become a byword for difficulty among the artists, as Derek explains: "The biggest struggle I've had in drawing a caricature. Ever. It took 45 full or partial drawings to achieve the finished likeness."

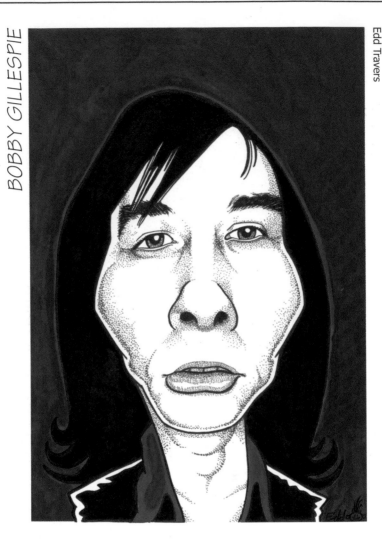

BOBBY GILLESPIE

Edd Travers

Robert Gillespie Jnr was born in Springburn, Glasgow in 1962. He founded Primal Scream in 1984, initially playing bass as well as performing lead vocals with the group. Their eclectic influences and ever-changing sound—encompassing punk, techno, pop/rock and more—have ensured their continued presence at the cutting edge of new music. Their third album, *Screamadelica*, was a groundbreaking effort that brought alternative sounds into the mainstream and won the first Mercury Music Prize in 1992.

❑

Derek: "The way Edd has painted this makes Gillespie look like the Devil incarnate—a perfect representation for one of rock 'n' roll's wild men! This is a great example of how colour, expression and pose combine to suggest the personality of the subject."

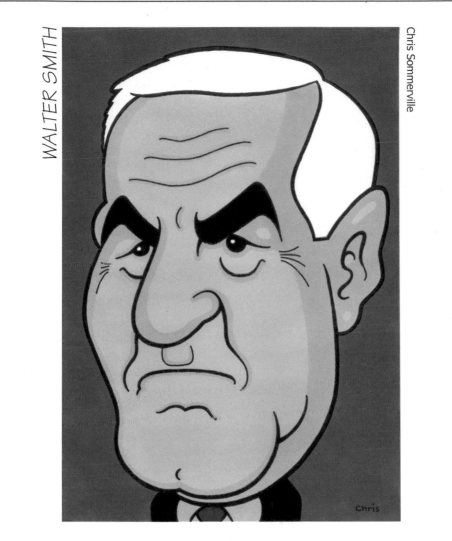

WALTER SMITH

Chris Sommerville

Chris

Born in 1948 in Lanark, Smith grew up in Carmyle in the east end of Glasgow. As a boy he idolised Rangers, a club he'd later manage. He trained as an electrician and worked at the South of Scotland Electricity Board before launching his football playing career in the 60s. He is better known for his record as a manager at Dundee United, Rangers and Everton. He is currently in charge of Scotland's national squad.

❑

Chris: "I really didn't want to tackle Walter—I kept looking at his photos and telling myself he was too difficult to caricature. I couldn't believe my luck when I nailed the drawing first time. It has that glum look typical not only of Walter himself, but of anyone asked to manage Scotland, God help him."

CAROL SMILLIE

Tommy Sommerville

Born in Glasgow in 1961, Carol studied fashion at Glasgow School of Art. She began her career as a model and got her first television job as a glamorous assistant on the British version of American game show *Wheel of Fortune*. Thereafter she found enormous success with the BBC's home make-over show *Changing Rooms*, which has spawned an entire genre of design and DIY programmes. She has risen to become one of the highest earning women in television.

Terry Anderson

GLEN MICHAEL

Ayr's Glen Michael, born 1926, was a contemporary of and collaborator with Rikki Fulton and Jack Milroy (pp. 4-5 and 83) and appeared in every series of *Francie and Josie* as well as in panto with the pair. Glen Michael's *Cartoon Cavalcade*, his Sunday afternoon children's programme, ran for a record-breaking 26 years on STV. Today he broadcasts on Saga Radio in Glasgow.

❑

Terry: "If you were a kid in Scotland in the 70s and 80s, Glen Michael was like your favourite uncle, Rolf Harris, Tony Hart and Walt Disney in one. I vividly recall watching his show, a mixture of the twee (home-made birthday cards, Rusty the dog), the fun (that catchy theme tune!) and the frankly terrifying (Paladin the phlegmatic talking oil lamp)."

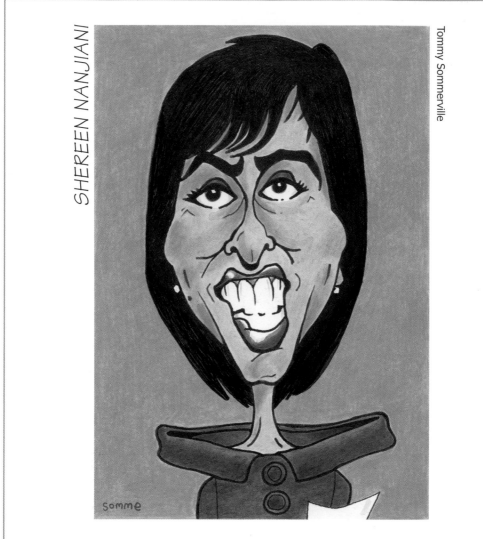

SHEREEN NANJIANI

Tommy Sommerville

somme

Shereen Nanjiani was born in Elderslie, Renfrewshire in 1961. She joined Scottish Television straight from university in 1983 and was the main presenter of *Scotland Today* for nearly two decades. Over the years she has reported on all the major stories affecting Scotland: the Piper Alpha disaster, the Dunblane massacre, the opening of the new Scottish Parliament and the death of Donald Dewar. As a result hers has become one of the most familiar faces in the country.

❏

Tommy: "Shereen's was one of the very first caricatures I'd done, working from photos in which her hair was short. Over the months I found myself adding more and more hair to the finished drawing, and I can't help but worry that by the time you read this she'll have had a haircut!"

Derek Gray

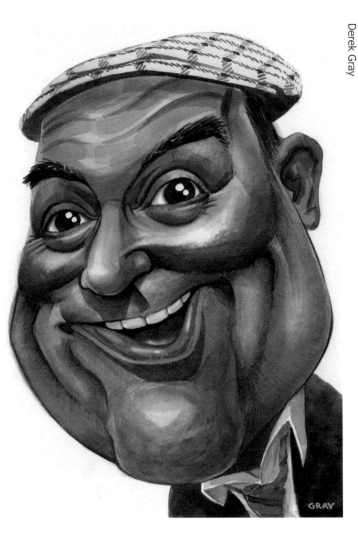

GRAY

Chic Murray was perhaps Scotland's best-loved stand-up comedian. He was born in Greenock in 1919 and formed a musical double-act with his diminutive wife Maida Dickson ("The Tall Droll with the Small Doll"). Later he pursued a solo career performing the surreal and absurdist humour that he is especially remembered for. He died in 1985, and many modern comedians, not least Billy Connolly (p.106), cite him as a major influence.

❏

Annabel Meredith, Chic's daughter, relates the family's reaction to the caricature: "We were all gob-smacked. It captures dad perfectly. He would have been flattered by his inclusion and overwhelmed by the caricature, especially the eyes. He often said they were 'the windows of the soul' and I think all the sparkle, as well as the pathos, he had in life is there."

GREG HEMPHILL

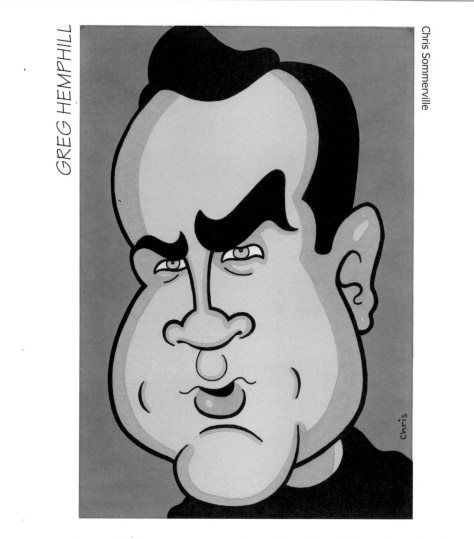

Chris Sommerville

Comedian, television and radio presenter, Hemphill was born in Glasgow in 1970, but spent much of his childhood in Montreal, Canada, which has given him a unique Scottish/Canadian accent. He is most famous as one half of the *Chewin' the Fat* and *Still Game* team, in which he co-stars and co-writes with Ford Kiernan (opposite). He was Rector of the University of Glasgow from 2001 to 2004, and was widely praised for taking an active interest in the role, unlike some past celebrity incumbents. He is married to Julie Wilson Nimmo (p.98).

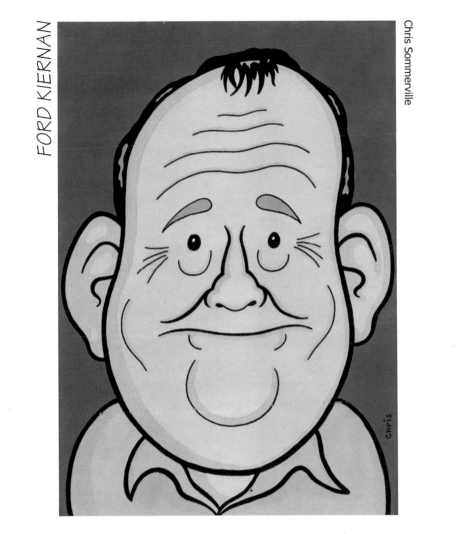

FORD KIERNAN

Chris Sommerville

Born in Dennistoun in 1962, Kiernan is known as a talented comedian, singer and mimic and is most noted for his acting and writing on popular television series *Chewin' the Fat* and *Still Game*, especially as Jack opposite Greg Hemphill's Victor (opposite). He has also regularly broadcast on BBC Radio 4 and Radio Scotland, and has worked extensively in theatre.

Brian: "From the start, Chris and I have used a very similar colour technique, although I occasionally add in mixed media for blemishes, sheens or shadows on certain faces. Chris's more graphic style looks great and the flat, solid colours show a confidence I feel I lack."

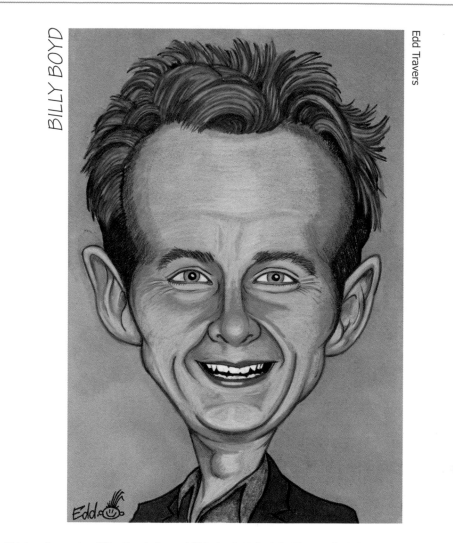

BILLY BOYD

Edd Travers

Edd

Glaswegian actor Billy Boyd, born 1968, is also a talented musician, graduate of the Royal Scottish Academy of Music & Drama, and former bookbinder. Literature would serve as his gateway to international stardom, playing impulsive Hobbit Peregrin Took in the three big-screen adaptations of JRR Tolkein's *The Lord of the Rings.*

❏

Terry: "Edd's not fond of fantasy, and claimed to have no idea who Billy Boyd was when he started work on this caricature. Despite that lack of familiarity, he's achieved a terrific likeness."

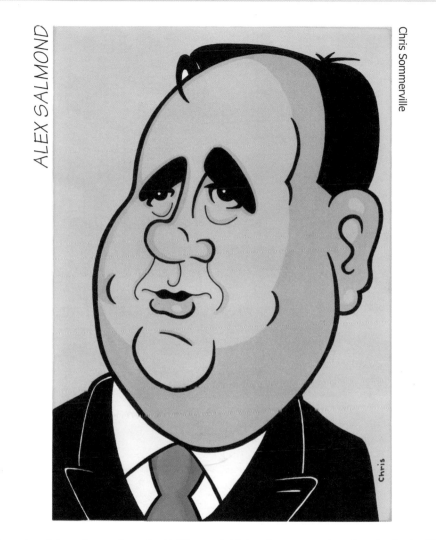

ALEX SALMOND

Chris Sommerville

Alexander Salmond was born in Linlithgow in 1954. He studied at St Andrews University where he first became involved in politics. He was elected National Convenor and Leader of the Scottish National Party in 1990, promoting their policy of "Independence in Europe". After a brief hiatus, he was re-elected as leader in 2004. Although currently a Westminster MP, he has vowed to stand for election to the Scottish Parliament. Politics is undoubtedly his passion, but Salmond is also a well-respected racing pundit.

ANNIE LENNOX

Edd Travers

Born on Christmas Day, 1954 in Aberdeen, Annie Lennox achieved worldwide fame with partner Dave Stewart as Eurythmics. In the 80s she was widely noted for her striking androgynous look, but it's her phenomenal voice and sharp intelligence that have brought continued success as a solo recording artist and contributor to soundtracks for major motion pictures. "Sweet Dreams" and "There Must Be An Angel" remain pop classics, and "Into the West", from the third *Lord of the Rings* film, won her an Oscar in 2004.

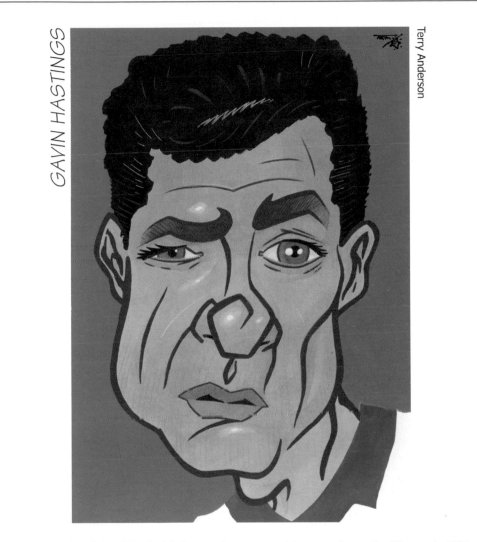

GAVIN HASTINGS

Terry Anderson

Born in Edinburgh in 1962, Gavin's long rugby career saw him captain Cambridge's Light Blues, Watsonians, London Scottish, the Barbarians, the British Lions and Scotland's national side. "Big Gav" was on the Grand Slam-winning team in 1990 and as captain secured Scotland's first away victory over France for 26 years in 1995. He retired from rugby that year, the second-highest test match scorer in the game's history, and during a brief spell with the Scottish Claymores American football team helped them to World Bowl victory in 1996.

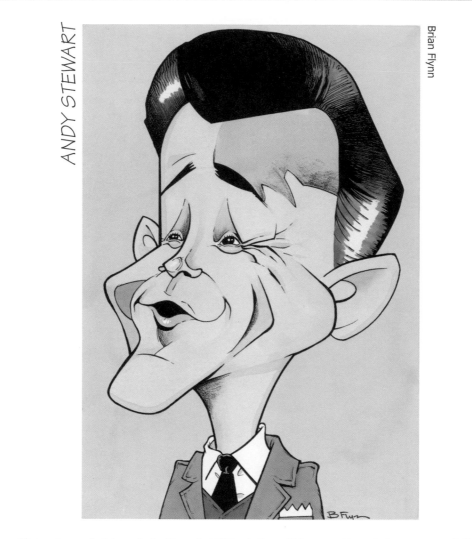

Brian Flynn

Glaswegian entertainer Andy Stewart (1933-1994) will always be remembered for his many television appearances on *The White Heather Club* and his signature tunes, "Ye Canny Shove Yer Granny Off a Bus" and "Donald, Where's Yer Troosers?"

❏

Terry: "It's unusual to caricature someone in the act of speech or song. People are more accustomed to seeing smiles or frowns in conventional portraits and photographs. But Brian's choice, along with the 'fifties-ish' colours, makes for a highly evocative drawing."

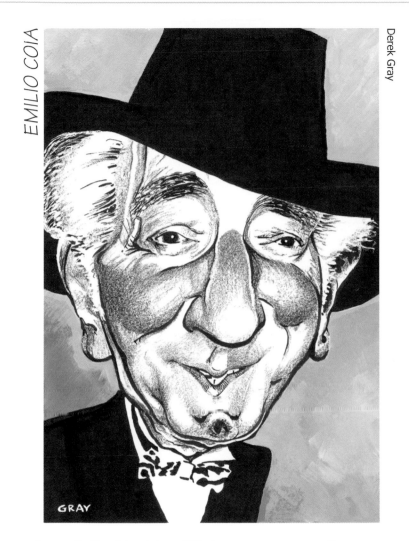

EMILIO COIA

Derek Gray

GRAY

The ever-dapper Emilio Coia (1911-1997) was born in Glasgow and drew caricatures for Glasgow's *Evening Times* before becoming the *Scotsman*'s resident caricaturist for nearly 50 years. He also became a well-known face on television, appearing as an artist on STV. Coia's caricatures ranged from minimalist chalk drawings to full-colour paintings and have been long admired by connoisseurs of the art form.

❏

Tommy is one of them: "Coia's the man who inspired me to become a caricaturist. After school I would run home in order to catch him on TV, and whilst my mates played football in the street I watched him draw. I originally wanted to draw Emilio but felt someone more talented was needed—Del's caricature speaks for itself."

GORDON STRACHAN

Chris Sommerville

Born in Edinburgh in 1957, Strachan has worn Dundee, Aberdeen, Manchester United, Leeds United and Coventry City jerseys during his highly successful playing career. He also won 50 international caps for Scotland and is a member of the Scottish Football Hall of Fame. He is currently the manager of Celtic.

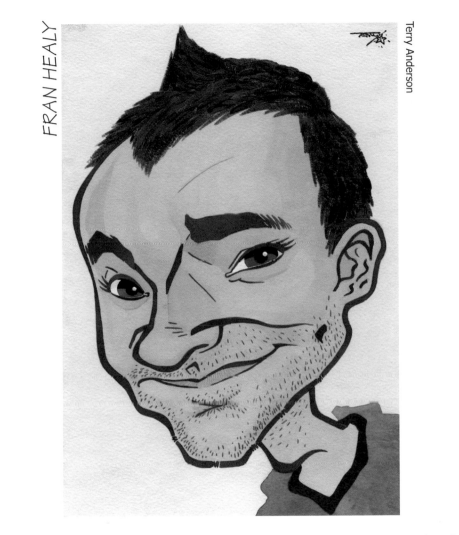

FRAN HEALY

Terry Anderson

Francis Healy was born in Stafford, near Birming-ham in 1973. While a student at the Glasgow School of Art in the mid-90s, he and three friends formed Travis, famously rehearsing in a room above the city's Horseshoe Bar. The band were championed by Noel Gallagher of Oasis, and in 1999 they released *The Man Who*, an album that, along with singles "Why Does It Always Rain On Me" and "Turn", made them into modern musical icons. In 2005 Healy lent his support to the Make Poverty History campaign.

❏

Brian: "I remember in the very early days Terry turned in a drawing of all four members of Travis, but he went back and focussed on Fran when it became obvious that individual shots made for better, more detailed caricatures."

Edd Travers

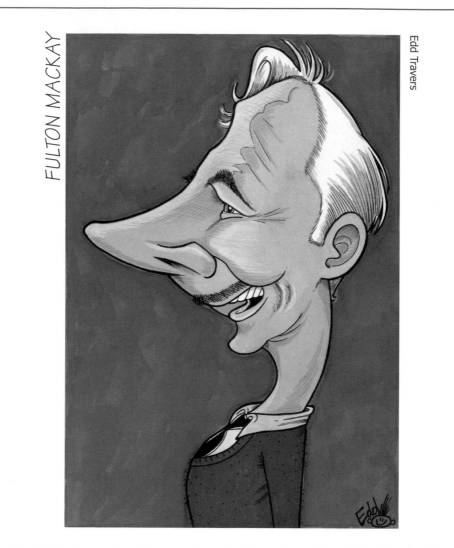

Paisley's Fulton Mackay (1922-1987) went into acting after serving with the Black Watch during the Second World War. His military experience informed his performance as tightly-wound prison warder Mr Mackay on 70s TV sitcom *Porridge*. He was just as accomplished a stage actor and also penned several plays under a pseudonym. In the last years of his life he appeared on the big screen as eccentric hermit Ben Knox in *Local Hero* and on children's television as a friendly lighthouse keeper on *Fraggle Rock*.

❑

Edd: "This piece is one of my personal favourites. It was produced from a single pencil sketch made whilst watching *Porridge* on TV. It's not often a caricature comes that quickly and easily, but this one did. If only the rest were as simple!"

Brian Flynn

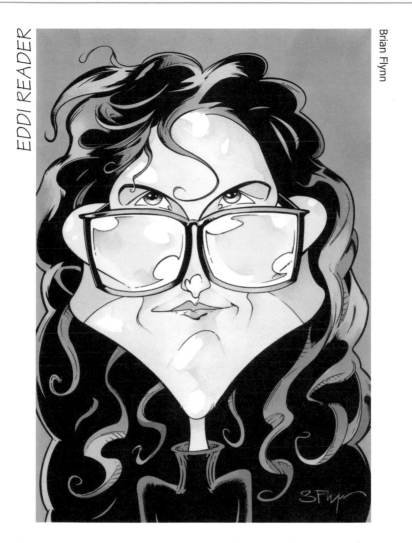

Born in 1959 and raised in Glasgow, Sadenia Reader paid her dues touring Europe with a circus group of performing artists. After settling in London she sang background vocals with Eurythmics (p.34) and then scored her most memorable hit, "Perfect", as lead singer with Fairground Attraction. She performs as a successful folk artist to this day.

BILL SHANKLY

Derek Gray

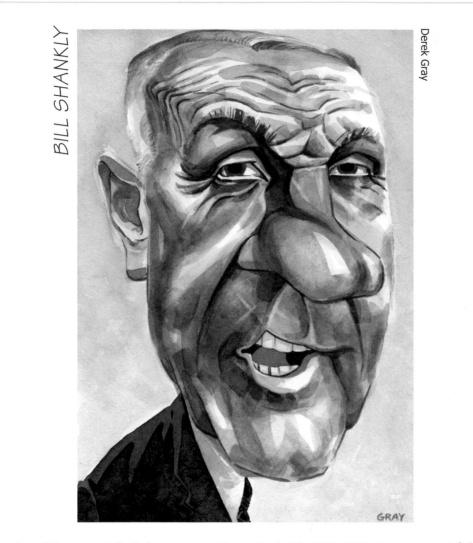

GRAY

One of the greatest football managers in the history of the game, Bill Shankly was born in the Ayrshire village of Glenbuck in 1913. His achievements at Liverpool FC between 1959 and 1974 are legendary, but the 1972/73 season in particular saw his team take the First Division championship and win the UEFA Cup.

He died in 1981. While his statue at Anfield bears the inscription "He Made the People Happy", a more fitting epitaph might be his oft-quoted words: "Some people think football is a matter of life and death... I can assure them it is much more serious than that."

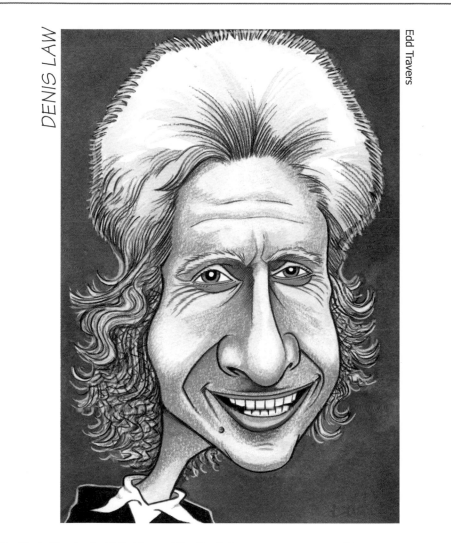

DENIS LAW

Edd Travers

Familiar to Manchester United fans as "the King" and "the Lawman", Denis was born in Aberdeen in 1940. In an 18-year footballing career he played for Manchester City as well as United, Huddersfield Town, Torino and the Scottish national side. European Footballer of the Year in 1964, he scored a massive 236 goals for United and 30 goals for Scotland. He remains a popular football pundit on TV and radio.

❏

Edd: "Try as I might, I couldn't find any photos that showed Denis's eye colour. In desperation, I telephoned Old Trafford, only to be put straight through to his daughter Louise! I had to assure her that I wasn't some stalker, and thanked her profusely for confirming her father's eyes as being blue."

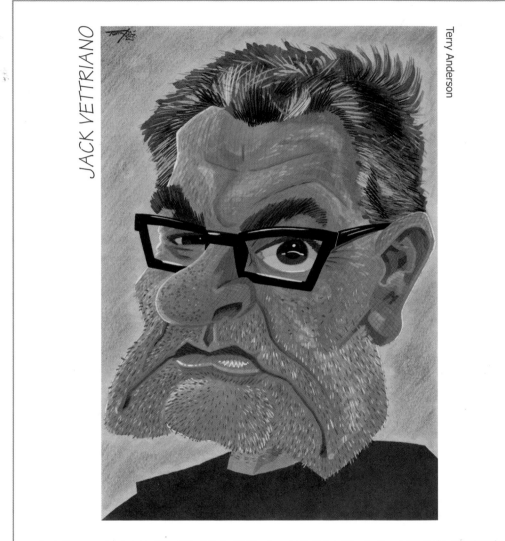

JACK VETTRIANO

Terry Anderson

Jack Hoggan, born near Kirkcaldy, Fife in 1951, made his debut as an artist under the name of his Italian grandfather at the 1988 Royal Scottish Academy annual show. He's never looked back. One of the world's most commercially successful painters, the self-taught Vettriano's work is romantic and erotic, heavily influenced by the fashion and films of the 50s. Critics may dismiss his paintings as pastiche, but the public and private collectors alike can't get enough.

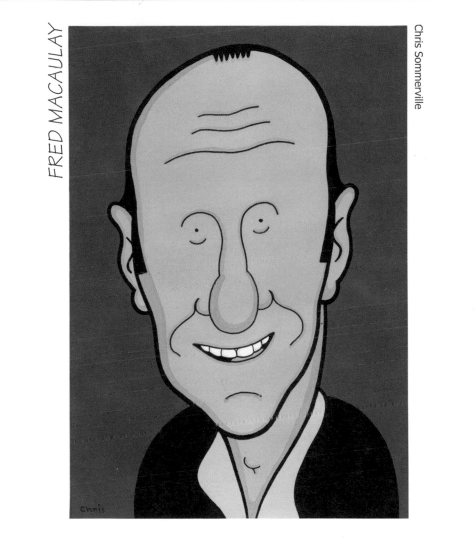

FRED MACAULAY

Chris Sommerville

Chris

Fred MacAulay was born in 1956 in Perth. He moved to Glasgow to try his hand at comedy, having previously worked as an accountant. In 1989 he debuted at the city's Funny Farm and the legendary Comedy Store in London. Soon he was working as a warm-up act for Rory Bremner and Paul Merton among others. Television and radio opportunities followed, and today he's a fixture on Radio Scotland's morning slot.

❑

Chris: "I have to admit to struggling quite a bit with Fred. He has limited features: not much hair, no glasses or beard, nothing to really base the drawing around. But in the end I really grew to like this caricature."

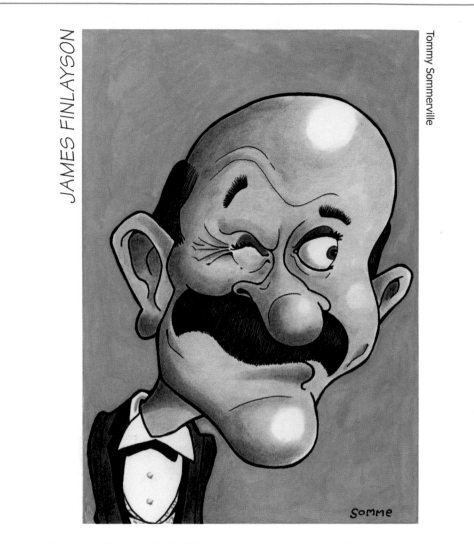

Tommy Sommerville

SOMME

James Henderson Finlayson (1887-1953), nick-named "Fin", was born in Falkirk but made his name in Hollywood. Audiences all over the world rocked with laughter at his on-screen antics throughout the 1930s and 40s, and never more so than when he played stooge to Laurel and Hardy. His look was unmistakable, although the moustache was false. Matt Groening, creator of *The Simpsons*, has confirmed that voice actor Dan Castellaneta based Homer Simpson's "D'oh!" on Finlayson's oft-heard cry of frustration.

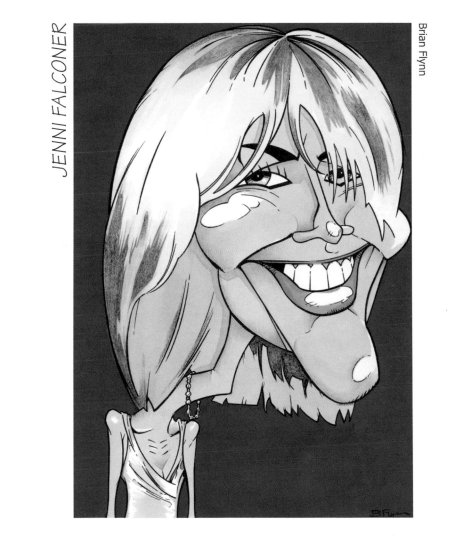

JENNI FALCONER

Brian Flynn

Jenni Falconer, born in 1976 in Glasgow, made her television debut as a contestant on *Blind Date* at the age of 18. Four years later she had become a familiar presenter to Scottish viewers and in 2000 reached a UK audience as host of GMTV's *Entertainment Today*.

❑

Derek: "Pretty girls are difficult to caricature; there is less to exaggerate and therefore it's more demanding for the artist. But Brian has plucked out a funny and perfect likeness. And check out that neck!"

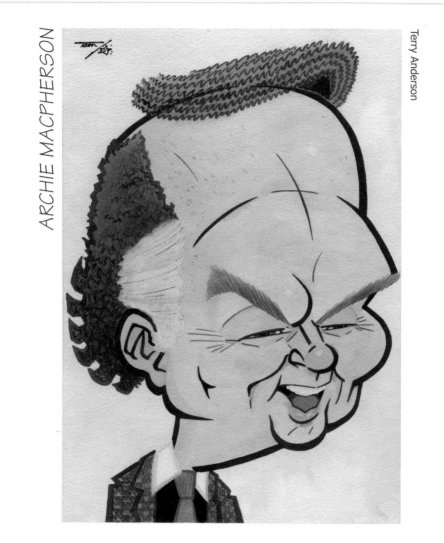

ARCHIE MACPHERSON

Terry Anderson

Glaswegian Archie Macpherson, born in 1937, is a veteran sports author, broadcaster and columnist. A former headmaster, he began his commentating career reporting for the BBC on Celtic's European Cup victory in Lisbon in 1967. He'd go on to cover seven consecutive World Cups and four Olympic Games before leaving BBC Scotland in 1990 to pursue a freelance career. He was presented with a Lifetime Achievement Award by BAFTA in 2005.

Arguably, no commentator's appearance has ever drawn as much comment; one of his distinctive coats can be seen at the Scottish Football Museum.

❏

Chris: "This is one of those caricatures that can't help but raise a laugh when you see it. Terry's colouring somehow makes the piece look like it was actually made in the 70s, just like Archie's jackets."

GORDON RAMSAY

Derek Gray

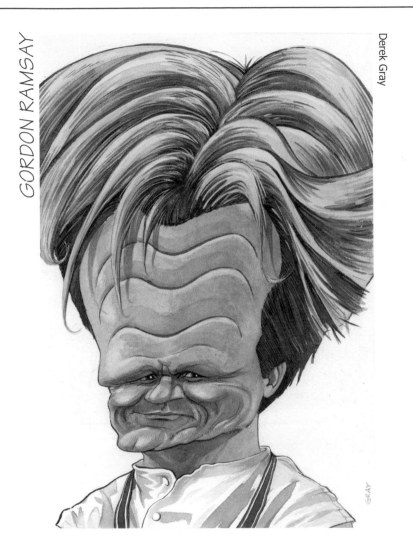

Top chef Gordon Ramsay, born in Elderslie, Renfrewshire in 1966, started out as a footballer for Rangers before a leg injury cut his career short. He then spent time in France studying cuisine before setting up his first restaurant in 1998. Today he is a world-renowned entrepreneur and broadcaster with many restaurants, books and TV shows to his name, and enjoys something of a reputation for his quick temper and blunt opinions!

❏

Derek: "When starting the initial drawing I was lacking a focus, a creative spark, to propel this caricature forward. Then, inspiration—I simply imagined Gordon's strong and ample forehead as a large side of ham!"

Terry Anderson

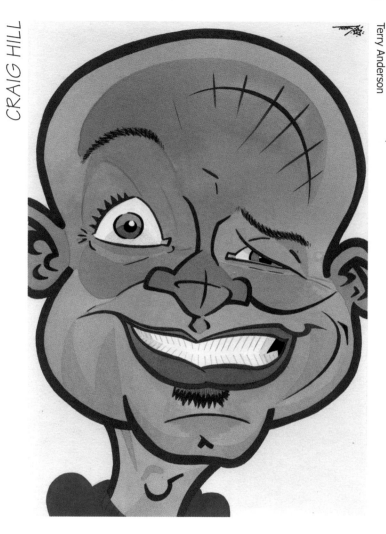

Comedian, mimic and television presenter Craig Hill was born in East Kilbride in 1969. With his penchant for kilts, distinctive shaven head and flamboyant persona, he's rapidly become one of the most recognisable faces on Scottish television. Having supported the likes of Johnny Vegas on tour and presented successful live shows at the Edinburgh Fringe, Hill currently hosts his own Friday night chat show.

Brian Flynn

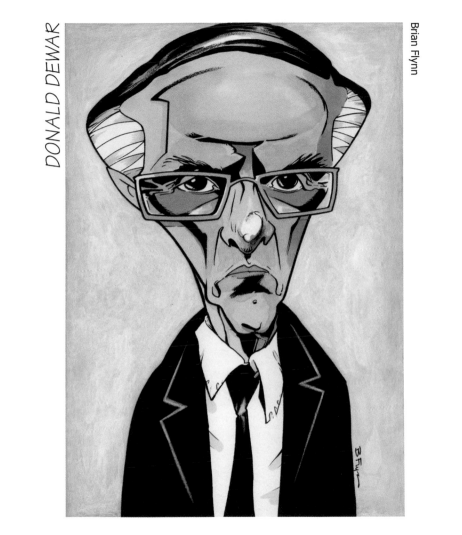

Donald Campbell Dewar (1931-2000) was born in Glasgow and joined the Labour Party while a student at the city's University, later becoming Chief Whip and then Secretary of State for Scotland after the election victory in 1997. The formation of the new Scottish Parliament after a hiatus of three centuries was the realisation of his life's ambition, and Dewar was elected the inaugural First Minister just months before his unexpected death. He will be remembered by many as "Father of the Nation".

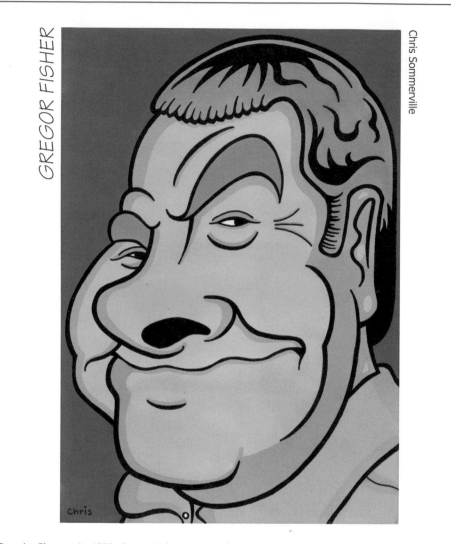

GREGOR FISHER

Chris Sommerville

Chris

Born in Glasgow in 1953, Gregor Fisher entered the Royal Scottish Academy of Music and Drama in Glasgow, but left before completing his studies. His first acting break came in the Dundee Repertory Theatre. Fisher's repertoire ranges from pantomime to classical theatre and from TV advertisements to feature films, but he is best known for his portrayal of the string-vested Glaswegian street philosopher in the television comedy series *Rab C Nesbitt*.

❏

Terry cites this as an example of "pure" caricature: "It would have been so easy for Chris to draw Fisher as Nesbitt, and let the stubble, string vest and bandage literally prop up the likeness. Instead, he's caricatured the real man, not the fictional character, and the piece is all the better for it."

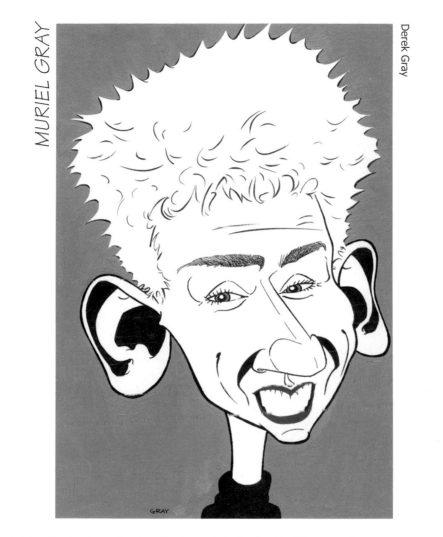

MURIEL GRAY

Derek Gray

GRAY

Muriel Gray is a leading writer, broadcaster and novelist. Born in East Kilbride in 1959, Gray made her TV debut in the 80s on seminal music show *The Tube* and later indulged her love of hillwalking on *The Munro Show*. In 1988 she was elected the first female Rector of the University of Edinburgh. Today she writes for the *Sunday Herald* among others.

❏

Derek: "When drawing Muriel I had *The Tube* era in mind. To that end I plumped for a black, grey, white and red colour scheme; appropriate as, throughout the decade, those were the colours decking out teenagers' bedrooms across the land."

DAVID SOLE

Derek Gray

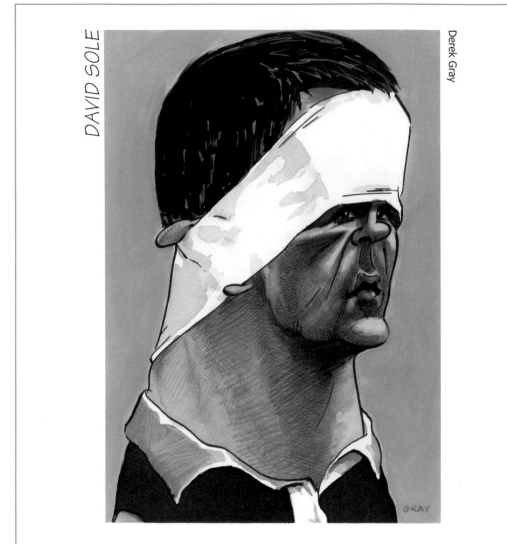

David Sole was born into a Scottish family in Aylesbury, Buckinghamshire in 1962 and grew up in Perthshire. He will always be remembered as the steely and determined captain of Scotland's 1990 Grand Slam-winning side. He won 44 caps playing rugby for Scotland and holds a record of 25 caps as a captain, a role he handed to Gavin Hastings (p.35) upon retirement in 1992. Today he works occasionally as an articulate and highly knowledgeable commentator on televised fixtures.

Somme

Singer/songwriter Donovan Philips Leitch was born in Glasgow in 1946 and began playing guitar at fourteen. He started writing original material in the early 60s and came to national prominence with his first single "Catch The Wind" in 1965. He became a close friend of the Beatles and during the period between 1966 and 1969 produced his most original and enduring work. He released a new album, *Beat Café*, in 2004.

❏

Tommy: "When I finished this drawing, I showed it to a mate of mine who commented, 'That's a crackin' drawing of Sigourney Weaver!' Nevertheless, we remain friends..."

DAVID TENNANT

Brian Flynn

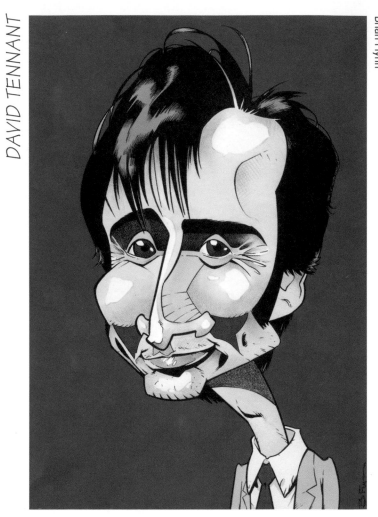

Born David MacDonald in Bathgate, West Lothian in 1971, this ascendant actor once wrote a school essay stating his desire to play the Doctor on BBC TV's *Doctor Who*. After impressing in such series as *Blackpool* and *Casanova*, as well as a cameo in *Harry Potter and the Goblet of Fire*, his childhood wish came true when he was cast as the 10th incarnation of the Timelord in 2005.

❏

The artist struggled with this piece. Says Brian: "No matter how I approached this drawing, I couldn't seem to get it right. Then I caught a magazine interview where David described himself as looking like a weasel... I nailed it immediately!"

SCOTT HARRISON

Chris Sommerville

Chris

Born in 1977 in Bellshill, Glasgow, Harrison has been described as "the best Scottish boxer for generations". He turned professional in 1996 and went on to win 18 of his 20 fights before taking the World Championship. Harrison took the Commonwealth Featherweight Championship in 2000 and added the British title in 2001. In 2002, he was crowned WBO Featherweight Champion at the Braehead Arena in his hometown.

❑

Chris got a first-hand look at his subject: "The weekend after I'd completed my caricature of Scott, I actually bumped into him in a pub up the West End, but I didn't have the bottle to let him know what I'd been up to!"

Derek Gray

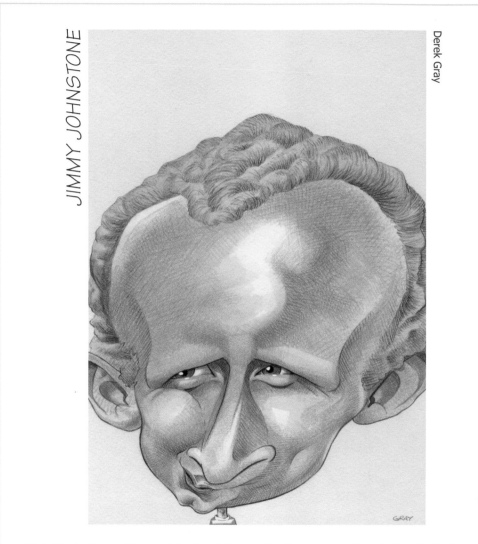

GRAY

"Jinky" Johnstone, nicknamed for his distinctive weaving run, was born in Bothwell in 1944 and is widely regarded as Celtic's greatest ever player. His diminutive stature and coppery hair made him an unmistakable figure on the pitch. He was part of the famous "Lisbon Lions" squad, winners of the European Cup in 1967 and the first British side to do so. Jinky was a contemporary of Jim Baxter (p.77) and the two legends were friends despite the intense rivalry between their two teams. Diagnosed with Motor Neurone Disease in 2001, Johnstone subsequently became a staunch advocate of stem cell research. He died in 2006.

❏

Terry: "It's not often we go for the familiar 'big head, wee body' pose, but when we do, as Derek has here, we really go for it."

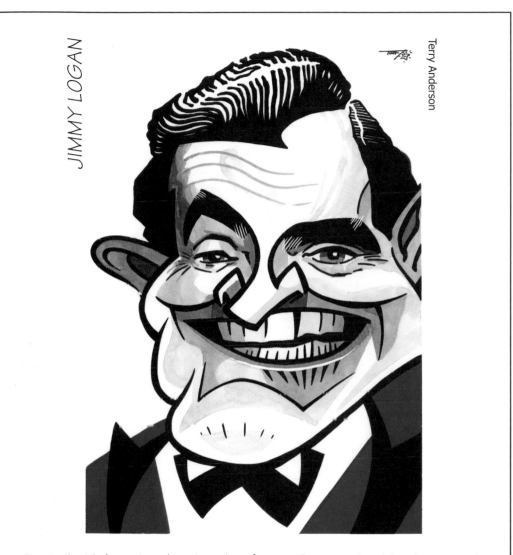

JIMMY LOGAN

Terry Anderson

Born to theatrical parents and on stage since childhood, Jimmy Logan (1928-2001) initially made an impression on theatregoers as a panto star. Throughout the 40s and 50s he continued to perform on stage, radio and film. With the spoils of his success he bought the Metropol Theatre in Glasgow, but was nearly ruined when the venue folded in the 70s. Jimmy picked up the pieces and in the final years of a career based largely on comedy and light entertainment he drew rave reviews for dramatic performances, especially his one-man show based on the life of Sir Harry Lauder (p.103).

❑

Terry: "As might be apparent, I was looking at old theatre posters and playbills for reference when caricaturing Jimmy."

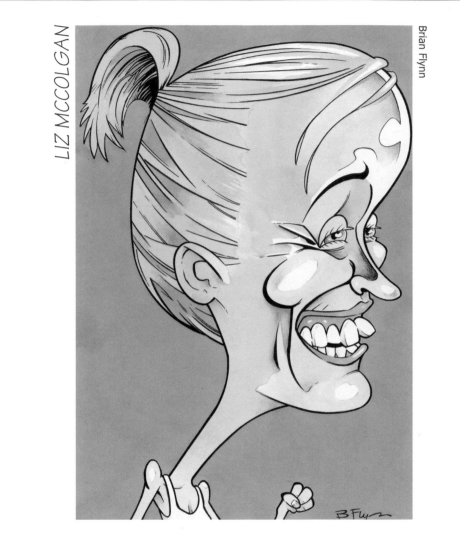

LIZ MCCOLGAN

Brian Flynn

Elizabeth McColgan was born in Dundee in 1964 and is the most successful long-distance runner in British athletics history. She won a gold medal at the 1986 Commonwealth Games, taking gold again for the 10,000 metres at the 1991 World Championships in Tokyo. Voted BBC Sports Personality of the Year for her achievement, she retired in 2001.

Tommy Sommerville

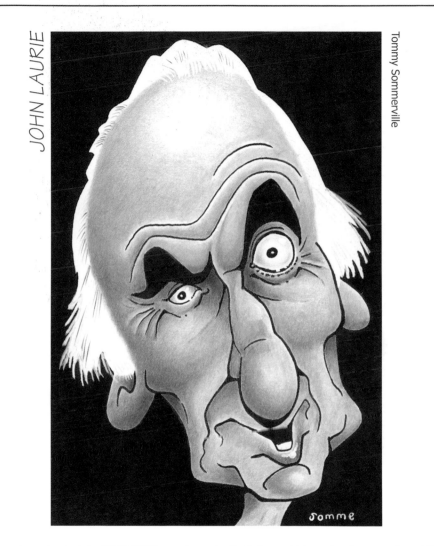

Character actor Laurie (1897-1980) was born in Dumfries, and was seen in more than a hundred films, including *Treasure Island* and *The 39 Steps*. His most famous role came late in life, that of Private Frazer in the television series *Dad's Army* which ran for nine years from 1968. His melancholy catch phrase, "Whur doomed!" became a firm favourite with the show's huge audience throughout the UK.

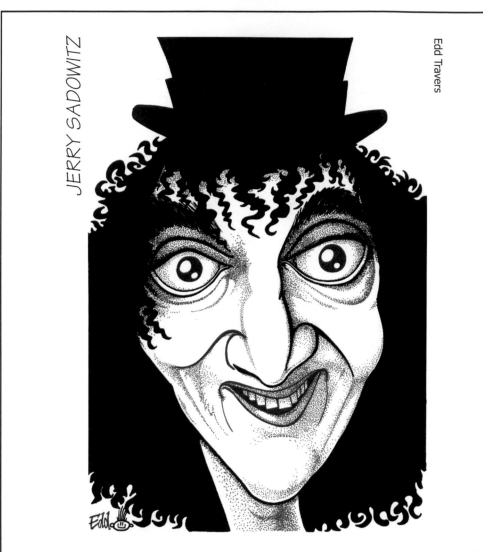

JERRY SADOWITZ

Edd Travers

Born in New Jersey, USA in 1961, Sadowitz was brought to Scotland as a child by his mother and grew up in Glasgow. He is a talented stage magician, widely acknowledged by those who know as the best sleight-of-hand man in the business, and has authored several books on card magic. However he has gained much greater infamy as the country's most unapologetically offensive stand-up comedian. Reviled, heckled and even assaulted by live audience members, and unwilling to dilute his act for television, he continues to break every imaginable taboo with thinly disguised glee.

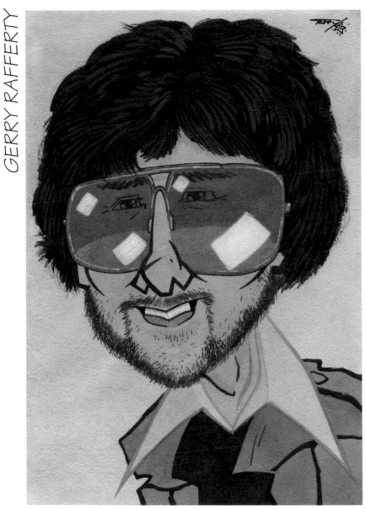

GERRY RAFFERTY

Terry Anderson

Born in Paisley in 1947, singer, songwriter and guitarist Gerry Rafferty spent the 60s playing in The Humblebums alongside Billy Connolly (p.106). With fellow Scot Joe Egan, Gerry garnered huge success in America as Stealers Wheel. Massive single "Stuck in the Middle With You" (1973) was the highlight of their four years together. A solo artist for some three decades, arguably his best-known tune is "Baker Street" (1978), featuring one of the most recognisable saxophone riffs ever recorded.

❏

Terry: "Rafferty has of course been drawn many a time by fellow son of Paisley John Byrne (p.67). I chose to portray him just as he looked when Byrne was producing artwork for albums such as Ferguslie Park. I can't compete, but I hope I've at least done something that contrasts with those iconic images."

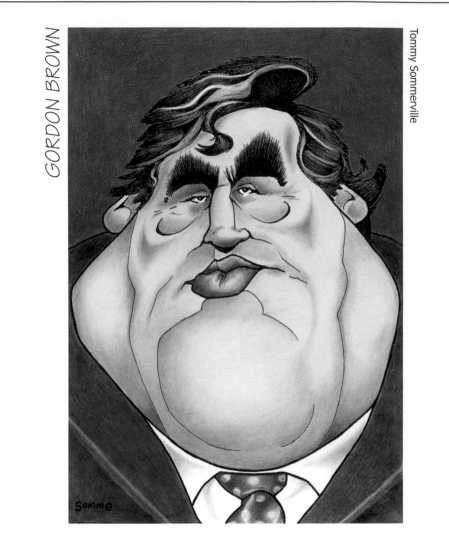

GORDON BROWN

Tommy Sommerville

Somme

James Gordon Brown was born in Glasgow in 1951. Educated at Kirkcaldy High School, he later studied history at the University of Edinburgh, where he gained first class honours and then a doctorate. Since boyhood he has supported Raith Rovers FC. Long a leading light within the Scottish Labour Party, Brown has served as Chancellor of the Exchequer of the United Kingdom since 1997.

❑

Terry: "Brown is actually blind in his left eye, which I think lends much to the power of his expression. Tommy's captured the bullishness the man brings to the dispatch box."

JOHN HANNAH

Brian Flynn

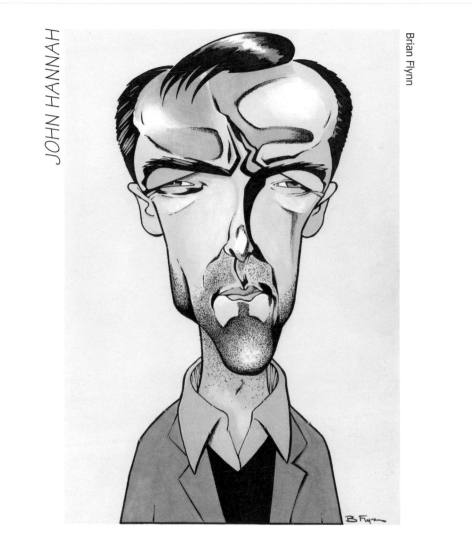

John Hannah was born in East Kilbride in 1962 and trained as an electrician before studying at the Royal Scottish Academy of Music and Drama. Familiar from film roles in British hits like *Four Weddings and a Funeral* and Hollywood fare such as *The Mummy*, Hannah has also starred in the title role in TV adaptations of Ian Rankin's Rebus novels (p.22).

Edd Travers

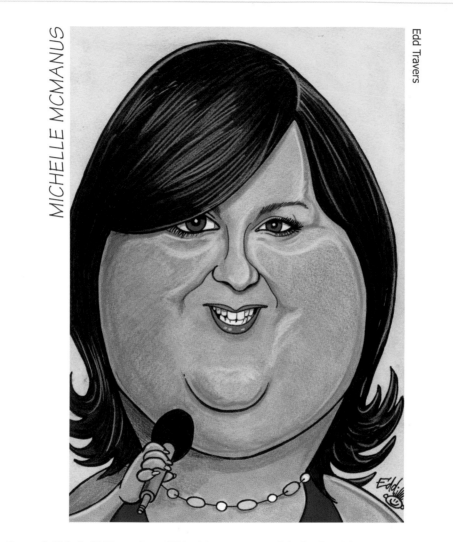

Glasgow's Michelle McManus, born 1980, shot to fame in 2003 as the winner of *Pop Idol*. Her subsequent single, "All This Time", spent three weeks at number one. Michelle's success challenged the stereotypical view of pop musicians, as many thought a woman her size could not compete in an image-conscious industry. Recently she has been working with TV nutritionist and fellow Scot Gillian McKeith, and it's reported she has lost eight stones.

❑

Edd bemoans the transformation: "This piece was done back in the days when Michelle had a 'fuller figure'. Pop stars are always changing their image, so the trick is to select the point in their careers at which they had the most impact." (See also Annie Lennox, p.34, Lulu, p.91.)

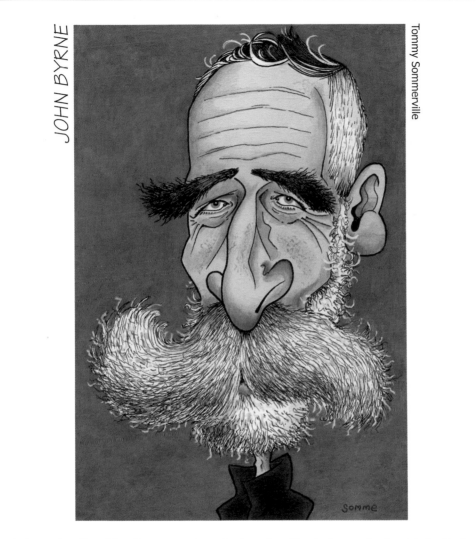

Somme

Artist and writer John Byrne was born in Paisley in 1940. A former student at the Glasgow School of Art, several of his paintings hang in the Scottish National Portrait Gallery in Edinburgh, including likenesses of his wife, actress Tilda Swinton, Robbie Coltrane (p.95) and a self-portrait. Byrne's artwork is familiar to fans of Gerry Rafferty (p.63), having provided distinctive record sleeve designs for his fellow "Buddie" during the 70s. His writing credits include plays and television series such as *The Slab Boys* and *Tutti Frutti*.

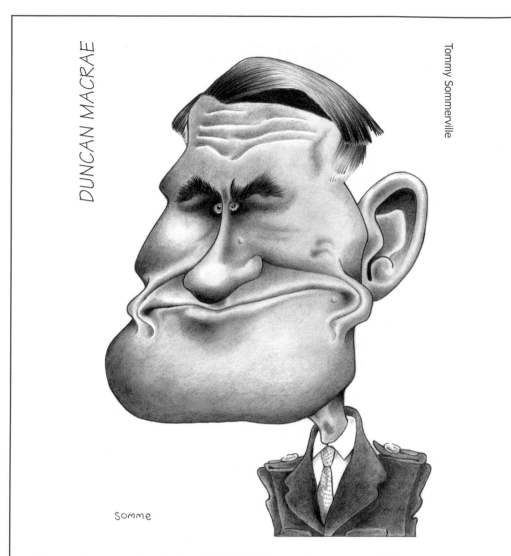

DUNCAN MACRAE

Tommy Sommerville

Somme

Stage and screen actor MacRae (1905-1967) was an ardent nationalist who associated himself closely with the Citizens' Theatre in Glasgow and was an active member of Equity, serving as Chairman of the union's Scottish Committee. His films include *Tunes of Glory* and the classic Ealing comedy *Whisky Galore!* He is also remembered for his portrayal of the captain of the disaster-prone Clyde puffer "The Vital Spark" in the classic BBC television comedy series *Para Handy*.

❏

Derek: "When caricaturing, there is always the question of where the limit is—the point where the drawing becomes so exaggerated that the likeness suffers. With this drawing Tommy has produced one of the more extreme caricatures in the book without losing the likeness. And I love the velvety richness of the pencil rendering."

Edd Travers

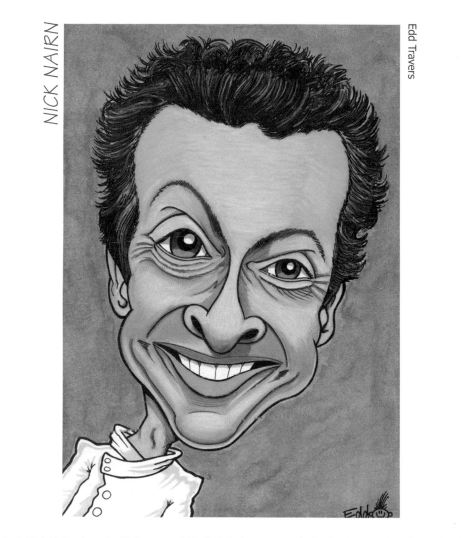

Ayr's Nick Nairn, born in 1959, opened his first restaurant in 1986, having had no formal training in cuisine. Five years later he was awarded a Michelin star, the youngest Scot ever to achieve the honour. A broadcaster and entrepreneur, he runs a catering business and cookery school as well as his restaurants, is the author of several best-selling books and continues to be a passionate advocate for Scottish produce and healthy eating.

SIR MATT BUSBY

Terry Anderson

Matthew Busby (1909-1994) came from the village of Orbiston, Lanarkshire. His career as a footballer was cut short by the war, but 1945 saw him take the helm at Manchester United, where he would make his mark as the first truly modern manager. A tragic plane crash outside Munich decimated "Busby's Babes" in 1958. Eight players died, but Busby's injuries didn't stop him forming the legendary United squad of the 60s—among them, Denis Law (p.43)—that became the first English team to win the European cup.

❏

Terry: "Readers might assume we've set out to draw people we admire, but I have no love or knowledge of football. Caricaturists have a responsibility to portray faces important and recognisable to their audience, and if you're talking Scotland, you're talking football."

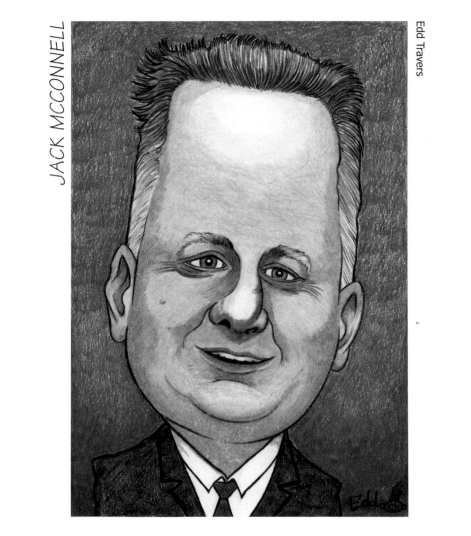

JACK McCONNELL

Edd Travers

Scotland's third First Minister since the formation of the new Scottish Parliament, Jack Wilson McConnell was born in Irvine in 1960, and raised on the Isle of Arran. After graduating from the University of Stirling and careers in teaching and local politics, he became General Secretary of the Scottish Labour Party in 1992 and Finance Minister in 1999. His premiership followed the untimely death of Donald Dewar (p.51) and the resignation of Dewar's successor, Henry McLeish.

❏

Edd: "This was the first ever *Fizzers* piece I produced. I remember the daunting but exciting feeling of beginning work on this big project. At the time, we were considering Jack McConnell as a possible writer of an introduction to the book, and therefore I'd need to be sure and make this one a cracker!"

Tommy Sommerville

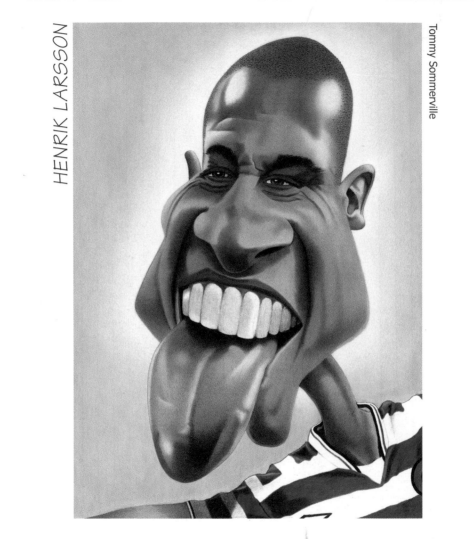

Born in Helsingborg, Sweden in 1971, Larsson began playing club football at the age of 5. He signed for Celtic in 1997, and his very first Old Firm season saw him score 16 goals in Glasgow. Celtic extended his contract by four years in 1999 and he scored his 100th goal in 2001. His consistently torrid pace saw him notch up a remarkable 53 goals for Celtic, which was enough to win him Europe's Golden Boot. Beloved by fans, his distinctive stuck-out tongue salute begat a great deal of merchandise, including caricatured Henrik masks.

Born in Leith, Edinburgh in 1958, Irvine Welsh blasted onto the literary scene in 1993 with his debut novel, *Trainspotting*. A bleakly comic tale of young heroin addicts set in his hometown, it inspired a movie of the same name and was a major part of the "Cool Britannia" culture in the mid-90s. *The Acid House, Marabou Stork Nightmares* and *Filth* were just some of the novels, short stories and plays that followed. He remains enamoured of life's seamier side, often explored in a conversational style so littered with slang, obscenities and pop-cultural references that readers outside Scotland's central belt are left dizzy.

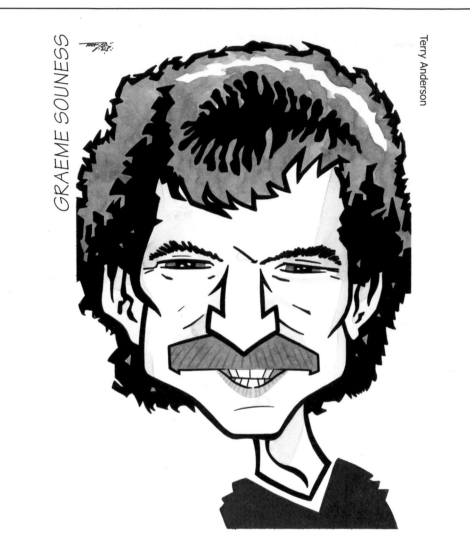

GRAEME SOUNESS

Terry Anderson

Born in Edinburgh in 1953, Graeme Souness—like so many other Scottish player/managers—has had an even bigger impact on English football. He played for Spurs and Middlesbrough before signing with Liverpool FC in 1977. Along with fellow Scots Alan Hansen and Kenny Dalglish (p.84), "Souey" would form the heart of a squad of champions over the next seven years. He ended his on-pitch career with four seasons at Rangers before taking over from Dalglish as manger of Liverpool in 1991. After a spell at Newcastle United, he is taking a break from football.

JOCKY WILSON

Derek Gray

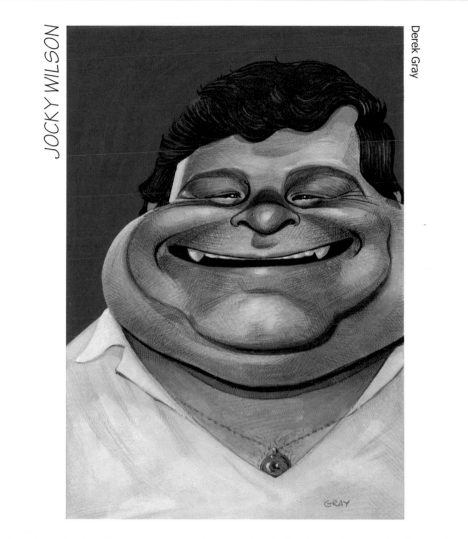

GRAY

Darts legend John, "Jocky" Wilson was born in Kirkcaldy in 1951. An extremely popular, if sometimes controversial character, he was British Professional Champion four times in the '80s, a record that remains unbroken. The pinnacle of his career came in 1982 when he won the Embassy World Professional Championship Trophy, the first Scot to do so. He fought back from a drop in form (he was briefly banned from the professional game after an alleged incident with an official) to become World Champion once again in 1989. Wilson retired shortly thereafter, but remains a legend in world darts.

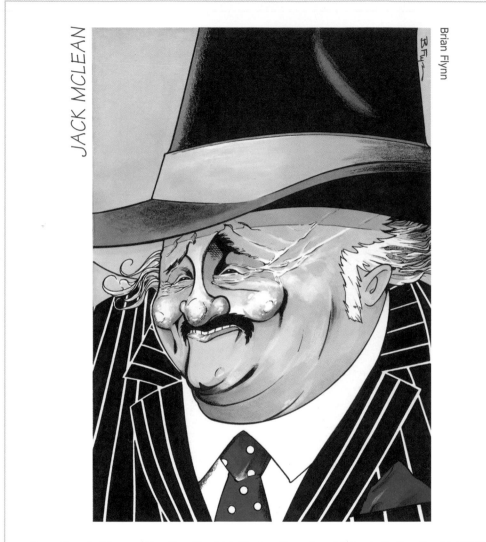

Brian Flynn

Brought up in Glasgow, the city with which his writing has become synonymous, McLean was born in Irvine in 1945. An art teacher turned journalist, he is an original, controversial and witty columnist for both the *Herald* and the *Scotsman*. His reputation in the national press is for never budging an inch from his opinions, even when they ruffle feathers.

Derek Gray

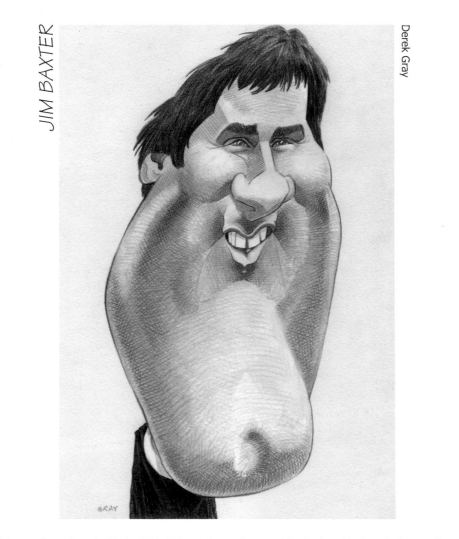

GRAY

"Slim Jim" was born in Fife in 1939. This much-loved footballer played for Rangers, Sunderland and Nottingham Forest, and won 34 caps for Scotland. After a public battle with the bottle and two liver transplants, Baxter appeared on the mend in the late 90s but died tragically in 2001 after doctors discovered cancer. Together with his friend and rival "Jinky" Johnstone (p.58), Baxter personified the Old Firm at its best.

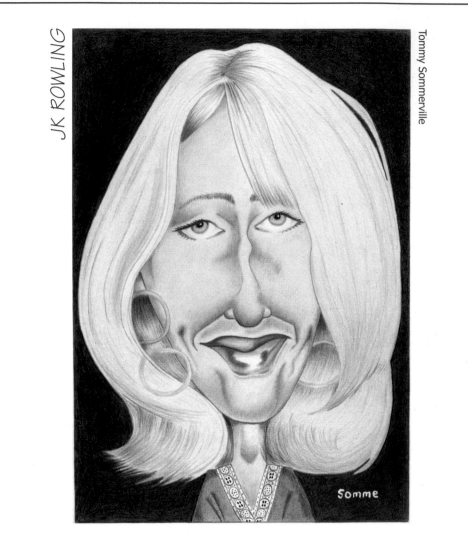

JK ROWLING

Tommy Sommerville

Somme

Joanne Kathleen Rowling was born in 1965 in Chipping Sodbury, South Gloucestershire. Rowling is the author of the phenomenally successful series of Harry Potter novels, which have gained international attention, won multiple awards and sold a reported 300 million copies worldwide. The books have been adapted into equally successful movies. She began work on her first novel after she and her daughter moved to Edinburgh in 1994 and the people of Scotland have since adopted both her and the boy wizard she created.

Born Russell Ellis in Glasgow, 1925, Hunter was a veteran character actor best known for his portrayal of seedy crook Lonely in *Callan*, the 70s TV thriller. As comfortable on stage as in front of the cameras, his long career encompassed a performance at the very first Edinburgh Fringe Festival and notable appearances on such television staples as *Taggart*, *The Sweeney* and *Doctor Who*. He passed away in 2004.

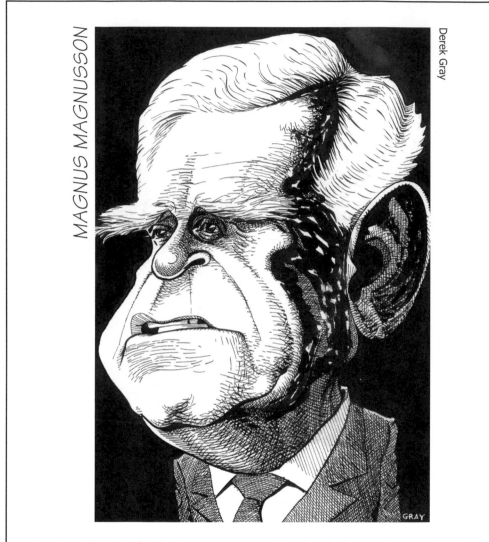

MAGNUS MAGNUSSON

Derek Gray

Born in 1929 in Reykjavik, Magnusson was brought to Edinburgh as a baby. He became a journalist with the *Scottish Daily Express* and then *Scotsman* newspapers, before joining the BBC where he became the original *Mastermind* quizmaster. Magnusson is a life-long conservationist and patron of many charitable causes.

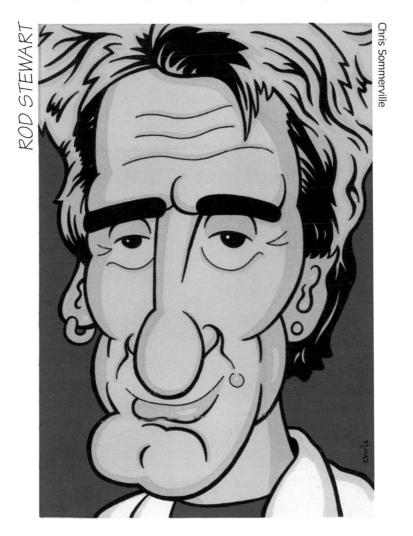

ROD STEWART

Chris Sommerville

Born in Highgate, London in 1945, the son of an Edinburgh plumber, Stewart began his career as an apprentice football player with Brentford, but soon followed his musical leanings and used his unmistakable singing voice to become one of the world's top rock stars. His biggest hits from the 70s, such as "Sailing", "Maggie May" and "Do Ya Think I'm Sexy", remain favourites to this day, although recently he has reinvented himself as a crooner. Stewart's love of Scottish football, and Celtic in particular, has helped cement him as a Scot in the eyes of the world.

PAT LALLY

Tommy Sommerville

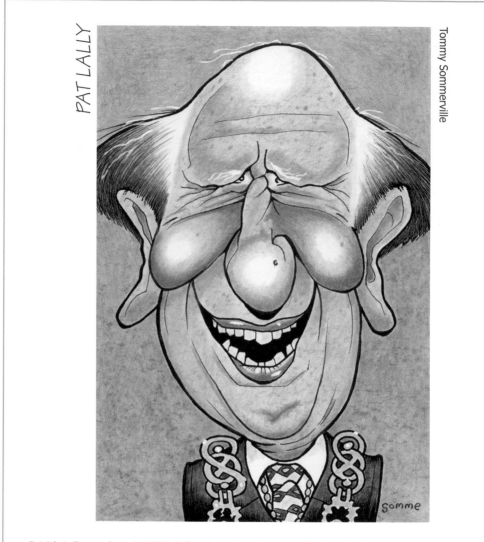

Patrick Lally was born in 1926. Before becoming Lord Provost of Glasgow in 1995, he played a major role in the planning of the 1988 Garden Festival, the completion of the city's Royal Concert Hall and Glasgow's designation as European City of Culture in 1990. Artist Peter Howson painted two portraits of Lally to celebrate his retirement, one of which, as a visual pun on his numerous political comebacks, portrayed him naked and emerging Lazarus-like from the tomb.

❑

Tommy: "Just before he retired, one of Lally's last official duties was to open the Scottish Cartoon Art Studio—fully clothed, I may add!" "I was hoping for a few more curls, but I'm afraid the likeness is all too accurate," says Pat. "My three-year-old granddaughter Sarah recognised me in it straight away!"

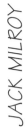

JACK MILROY

Brian Flynn

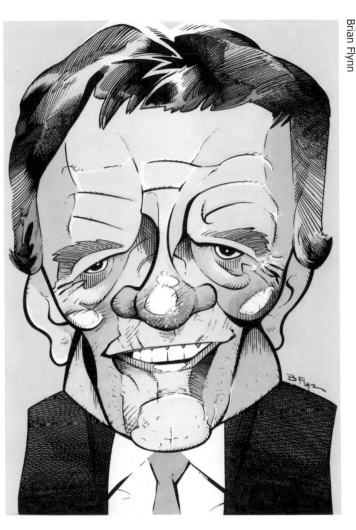

Born James Cruden in Govanhill, Glasgow, fans will always fondly remember Jack Milroy (1915-2001) as Francie to Rikki Fulton's Josie (pp.4-5). The pair's Teddy boy characters—always unlucky in love, with hearts of gold and heads full of mince—were created in 1960 and debuted on television two years later. The duo continued to entertain both television and theatre audiences until their farewell performance at the King's Theatre in 1996.

❑

Brian: "This illustration is really my first attempt. I just went straight into inks and then colour with no preparatory sketches, which is rare. Marti Pellow (p.93), for example, took nearly twenty practice runs before the likeness was right."

Brian Flynn

KENNY DALGLISH

A hero of Scottish football, Dalglish was born in Glasgow in 1951. Equally beloved by Celtic and Liverpool FC fans for his abilities on the pitch and in the dugout, he became Liverpool's first player/manager. As well as his 150 goals for Celtic, he's the only player to have scored 100 goals in both Scottish and English football.

JAMES COSMO

Derek Gray

James Cosmo was born in 1948 and grew up in Clydebank, Glasgow. A world-renowned actor with an unmistakable physical presence, James has appeared in such films as *Braveheart*, *Trainspotting* and *Troy*. Like many Scottish actors, he's often been seen in gritty dramatic roles, yet in 2005 he was cast in *The Chronicles of Narnia: The Lion, the Witch and the Wardrobe* as no less than Father Christmas himself.

❏

Says James of his caricature: "What a great piece of work! My congratulations and admiration to the artist. I'd love to buy it."

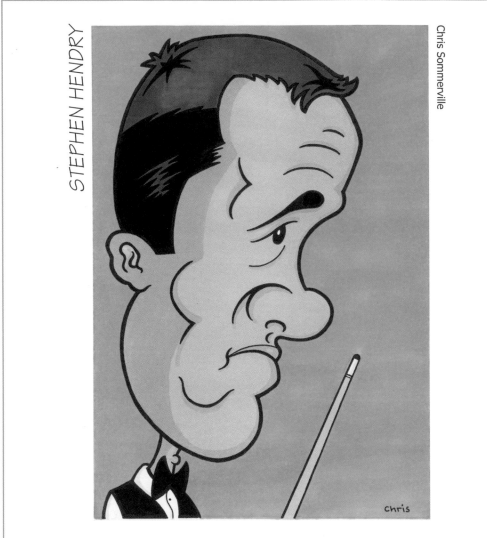

STEPHEN HENDRY

Chris Sommerville

chris

Edinburgh's Stephen Hendry, born 1969, made his professional snooker debut at the age of 16. His first Grand Prix win came two years later, and between 1990 and 1999 he claimed the World Championship seven times, meaning that he is not only the youngest to win the title but holds the record for most successes. Fans of the game consider him the greatest player Scotland has ever produced.

❑

Chris: "My style of caricature attempts to capture a strong likeness with as little line work as possible—sometimes an extremely difficult thing to do! I spent hours adjusting this drawing of Hendry, whilst trying to keep it simple and not too fussy. The final version is one of my best, I think."

Edd Travers

MAURICE ROËVES

Maurice Roëves was born in Sunderland in 1937. To many, he's become the archetypal Scottish "hard-man" actor, his granite features and gravelly voice seeing him cast in TV series such as *EastEnders*, *The Bill* and *Tutti Frutti*. However, a diverse career has seen him try his hand at period drama (*Last of the Mohicans*) and science fiction (*Judge Dredd*, *Star Trek*). He's even played God, in the screen adaptation of Irvine Welsh's *The Acid House* (p.73).

❑

Maurice was startled by Edd's caricature, in particular the artist's take on his jaw line. "A perfect example of 'Ah'll chin ye!'" says the actor.

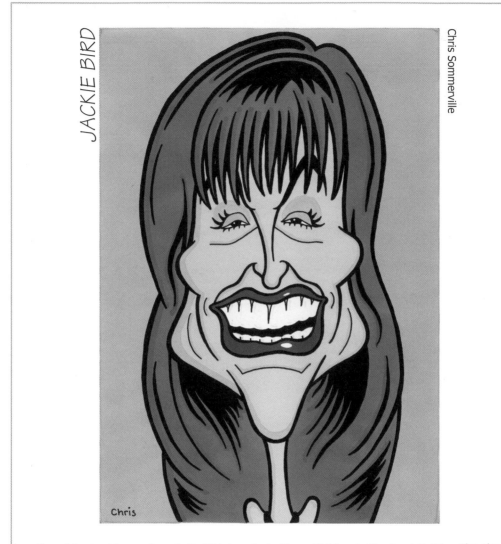

JACKIE BIRD

Chris Sommerville

Chris

One of the best-known faces in Scottish broad-casting, Jackie presents BBC Scotland's evening news bulletin *Reporting Scotland*, and is also called upon to host some of their most high-profile programming, including *The Hogmanay Show*, *Children in Need* and *Holiday*. She also writes and produces documentaries for trans-mission on television and radio. She was born in Bellshill, Glasgow in 1962.

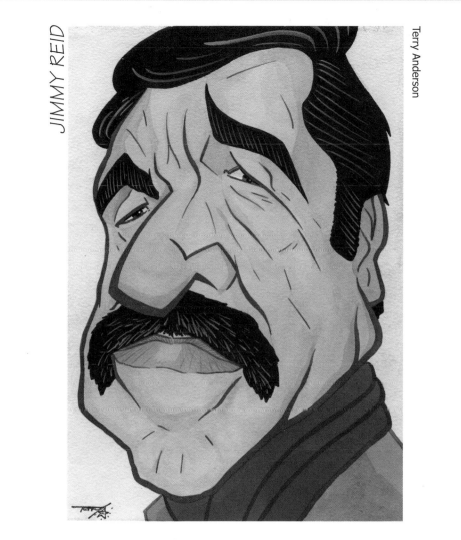

JIMMY REID

Terry Anderson

Born in Glasgow's Govan area in 1932, Reid first made headlines in the 70s as leader of the Upper Clyde Shipbuilders Work-In, the non-strike action that persuaded then Prime Minister Edward Heath not to close the city's shipyards. Later a councillor for Clydebank and Rector of the University of Glasgow, Reid stood for election as a Communist MP in 1974, arguably the last serious far-left campaign fought in Scotland until the advent of the SSP. Reid moderated his views in later life, joining first the Labour Party and then the SNP. He remains a well-respected and authoritative columnist and author.

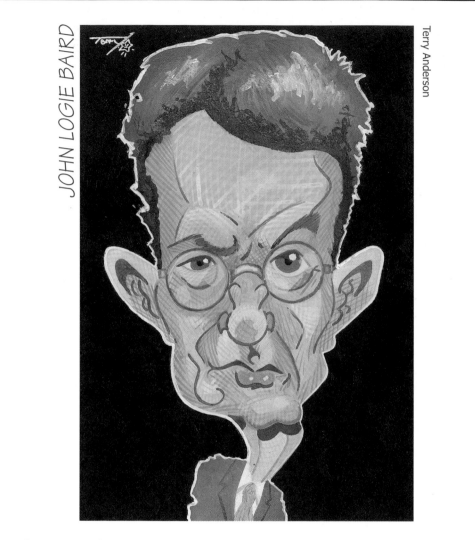

JOHN LOGIE BAIRD

Terry Anderson

John Logie Baird (1888-1946) was born in Helensburgh and later graduated from the University of Glasgow. Recognised around the world as a pioneer of television, Baird's technology—first demonstrated in 1926—was for many years the standard broadcasting system used by the BBC. Marconi's electronic system would ultimately supersede Baird's mechanical one, but the inventor was tireless in his innovation, and he successfully developed full colour, stereoscopic and big-screen TV systems as well as live and ultra-short wave transmission.

Derek Gray

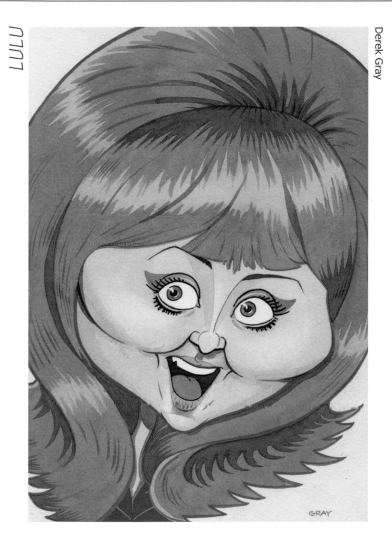

GRAY

Born Marie McDonald McLaughlin Lawrie in 1948, Lulu joined her first pop group aged only 14, playing the clubs of Glasgow. Her first single "Shout" was released in 1964. It became a smash hit and launched her to superstardom. She memorably performed the theme tunes for the movies *To Sir With Love* and *The Man With the Golden Gun*. She remains one of the UK's most popular singers and broadcasters.

❏

Derek: "With Lulu, we had to consider which point of her career to base the drawing on. It was decided I'd caricature her from the mid-60s purely because it made for the most interesting and evocative visual."

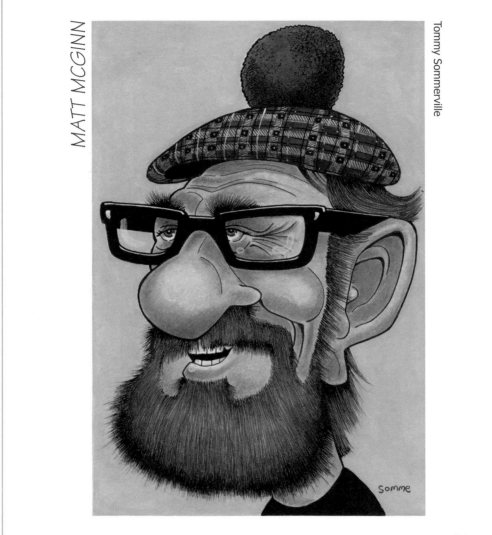

MATT McGINN

Tommy Sommerville

Somme

Glaswegian McGinn was born in the Gallowgate in 1928. Upon qualification he went to work as a teacher in Rutherglen. Thereafter he became a full-time comedian and singer, influencing the early career of Billy Connolly (p.106). His performances were hugely popular, often leaving the audience in tears of laughter. He was also a deeply committed radical in the tradition of Red Clydeside. Sadly he died in 1977 from the effects of smoke inhalation. A Glasgow pub bears his name to this day.

❏

Tommy: "I'm particularly pleased that Matt made the Studio's first caricature book. The younger guys in the studio didn't seem to know who he was, but I felt he was an important figure to pay tribute to."

MARTI PELLOW

Brian Flynn

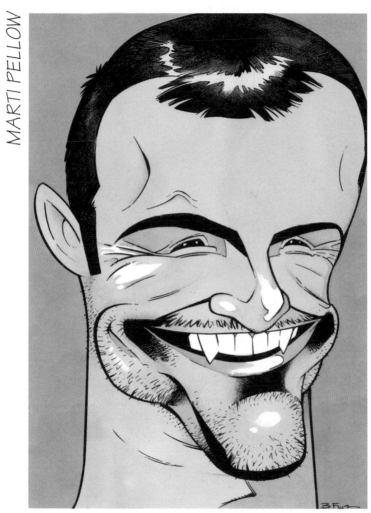

Born Mark McLachlan in Clydebank in 1965, Pellow formed pop group Vortex in 1985. They changed their name to Wet, Wet, Wet and twelve top ten hits followed, including "Wishing I Was Lucky" and their cover version of "Love Is All Around". Marti left the group in 1999 and embarked on a solo career. They reformed for the Scottish Live 8 concert in 2005, and began work on a new album soon thereafter.

❏

Edd had originally intended to draw the singer, but struggled to achieve a sufficiently strong likeness. At the same time, Brian was having problems with Russell Hunter (p.79). The artists swapped subjects, and two excellent caricatures were the result. "I love Brian's quirky, unique style of drawing—bizarre, surreal and very clever," says Edd.

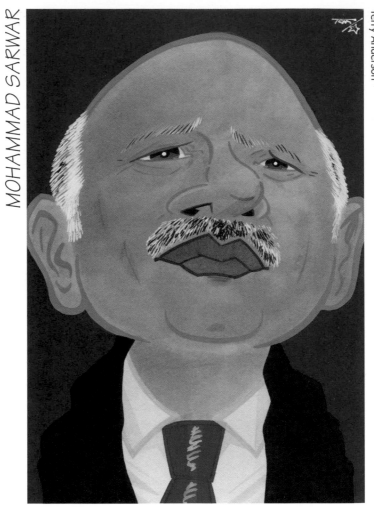

MOHAMMAD SARWAR

Terry Anderson

Mohammed Sarwar was born in Faisalabad, Pakistan in 1952. Arriving in Scotland at the age of 26, he became a retail millionaire and repatriated in 1987. Ten years later he stood as Labour's candidate in Glasgow Govan and was elected Britain's first practising Muslim Member of Parliament. His political career has been dogged by controversy, but nevertheless he has been returned to the Commons twice over by the people of Glasgow. A shrewd economist, he is a loyal supporter of Gordon Brown's Chancellorship.

Somme

Born Robert MacMillan in Rutherglen, Glasgow in 1950, Coltrane attended Glasgow School of Art before moving into acting. His comic skills saw him cast throughout the 80s in television series like *The Comic Strip Presents*, John Byrne's *Tutti Frutti* and *Blackadder*, but he displayed considerable dramatic talent in the 90s as criminal psychologist Fitz in *Cracker*. Children the world over love him best as the half-giant Rubeus Hagrid in the Harry Potter films. Author JK Rowling (p.78) has stated she had the actor in mind when she created the character.

❏

"My determination was certainly tested by this drawing: the first draft was ruined after spilling water; the second seemed gradually to resemble Johnny Vegas; in desperation, the third was finished during a week's retreat near Oban", smiles Tommy.

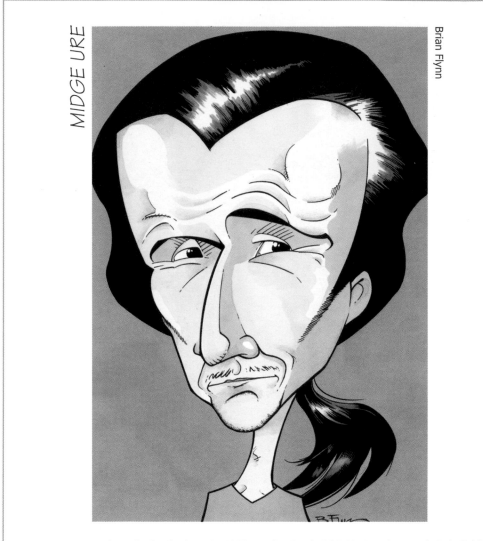

MIDGE URE

Brian Flynn

James Ure was born in Cambuslang in 1953. "Midge" is "Jim" phonetically reversed, a typical lyrical joke from this talented songwriter, singer and guitarist. After scoring several hits as lead vocalist with Ultravox, Ure spearheaded the Band Aid initiative along with Bob Geldof in 1984. He co-wrote the number one single "Do They Know It's Christmas", and was equally involved in the Live Aid and Live 8 concerts in 1985 and 2005.

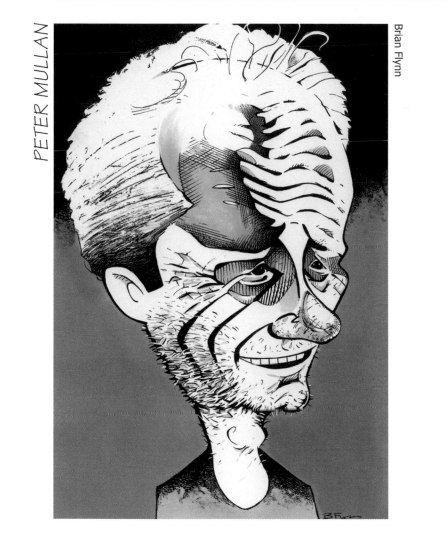

PETER MULLAN

Brian Flynn

Born in Bathgate in 1960, Peter Mullan spent his teenage years aspiring to direct films, but found a career, firstly, in acting. Having appeared in *Braveheart*, *Trainspotting*, and *My Name is Joe* to name but a few, Mullan drew critical acclaim for writing and directing such uncompromising dramas as *Orphans* and *The Magdalene Sisters*.

❑

Tommy: "As the appointed editor on the *Fizzers* project I was shown Brian's very first version of this piece, a small thumbnail sketch that he himself wasn't confident was up to scratch. However I felt all he had to do was enlarge and ink it, keeping it black and white. The rest of the lads agreed that—for some unknown reason—a rough and ready approach seemed to suit Mullan's features best."

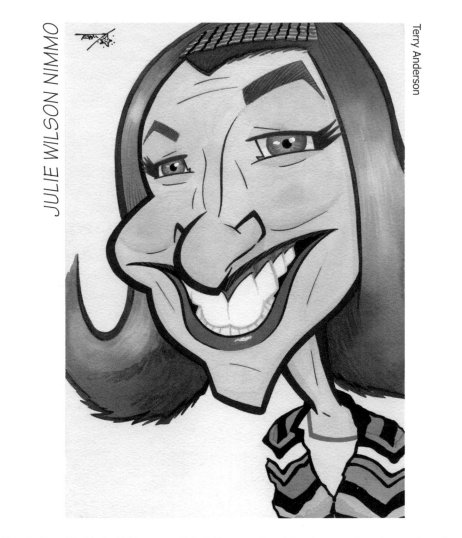

JULIE WILSON NIMMO

Terry Anderson

Born in East Kilbride in 1974, actress Julie Wilson Nimmo is best known as the green-clad, flick-haired nursery school teacher Miss Hoolie on children's television favourite *Balamory*. Since the show debuted in 2002, she has also played the character in sell-out national theatre tours. Married to Greg Hemphill (p.30), she recently announced her desire to bow out of the role as their own two children have been confused by the attention she receives from young fans in public.

❏

Derek: "Having two wee girls myself, I know this face well, and it's one of my favourites of Terry's pieces. He has completely captured the quirky energy of the actress. I can't look at it without smiling."

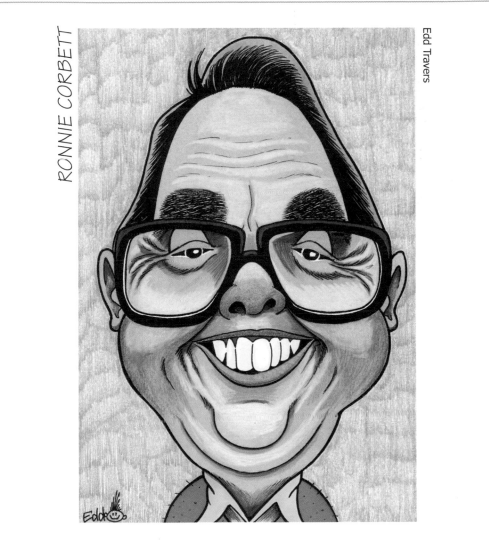

RONNIE CORBETT

Edd Travers

Edinburgh's Ronald Balfour Corbett, born 1930, first came to prominence along with John Cleese and Ronnie Barker on *The Frost Report* in the 60s. The legendary "Class" sketch made use of the actor's diminutive stature, something he would employ to comic effect time and again with partner Barker as *The Two Ronnies*. Their sketch show, with its fake news stories, musical interludes, word play ("Fork Handles" remains a textbook example of comedic writing and timing) and Corbett's circuitous monologues became familiar to British viewers throughout the 70s and 80s. He remains an active golfer and occasional performer, a hero to contemporary comedians such as Peter Kay.

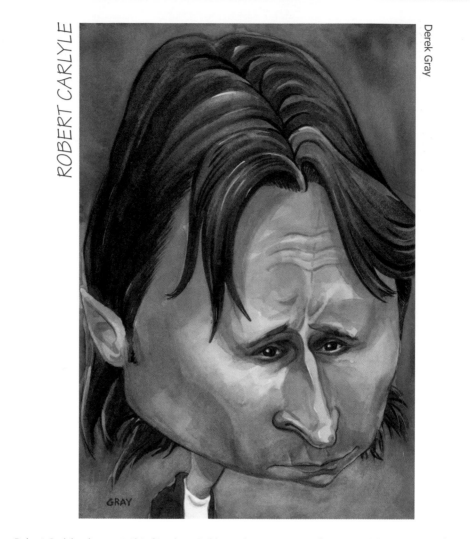

ROBERT CARLYLE

Derek Gray

GRAY

Robert Carlyle—known to his friends as Bobby—was born in Maryhill, Glasgow in 1961. He shot to fame in 1996 alongside Ewan McGregor (p.23) in the breakthrough British film *Trainspotting*, playing the violent psycho Begbie. Carlyle consolidated his position as one of the world's most recognisable big-screen Scots with both the lead role in *The Full Monty* and as Bond villain in *The World is Not Enough* two years later. He's equally familiar to TV viewers for memorable roles in *Cracker* and *Hamish Macbeth*, among others.

❏

Brian: "When Derek showed me this painting I couldn't help thinking he'd gone too far with the ears. But afterwards I looked at some photos and changed my mind. We all see people differently, and I wonder whether I'd have picked out the same details as Derek."

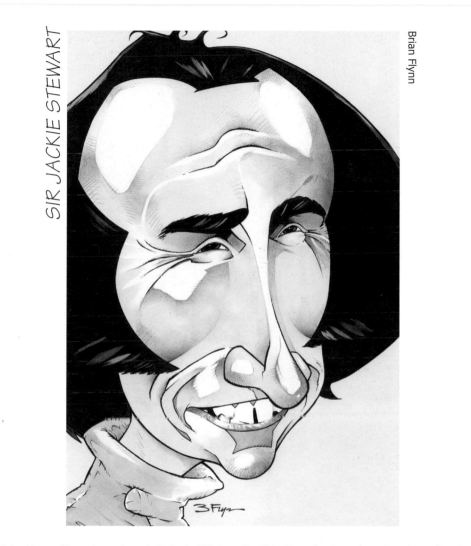

Brian Flynn

SIR JACKIE STEWART

John Young Stewart was born in Balloch, West Dumbartonshire in 1939. The family owned a garage, and it was there that Jackie began his lifelong relationship with motorcars as an apprentice mechanic. He went on to become Scottish Formula One champion three times over, and is beyond doubt the greatest racing driver the country has produced. Today, as well as being an active charity patron, he commentates on racing in the United States.

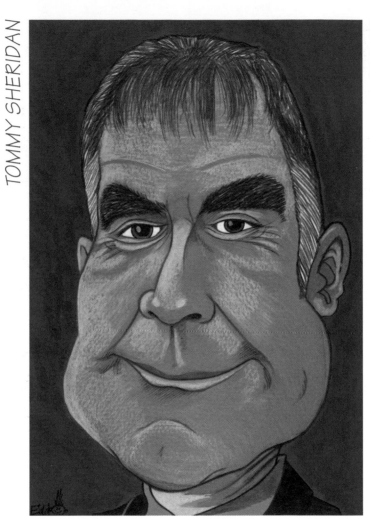

TOMMY SHERIDAN

Edd Travers

Born in Glasgow in 1964, Tommy Sheridan is a lifelong socialist, having initially been active within Scottish Militant Labour. After serving as councillor for Glasgow's Pollock ward, he became an MSP for the city in 1999. Sheridan was convener of the Scottish Socialist Alliance, later the Scottish Socialist Party. Many will remember him best for his highly publicised protests against the Poll Tax and nuclear weapons at Faslane, as he was only too willing to endure arrest and prison sentences for his principles. He is currently away from the frontline of politics, but remains within the SSP's executive ranks.

SIR HARRY LAUDER

Tommy Sommerville

Somme

Lauder (1870-1950) was born in Portobello, Edinburgh. Scotland's image in the world today owes much to the physical caricature he presented in his stage performances. The country's first international superstar, his career saw him play Carnegie Hall in New York and golf with Presidents.

Signature songs such as "I Love a Lassie" and "Roamin' in the Gloamin" were inspired by the love of his wife, and "Keep Right on to the End of the Road" was written after his son was killed in action in the First World War.

This popular singer was born in Glasgow in 1967. She began her career as a hairdresser before finding success as lead vocalist with Texas, the band she still fronts after some 20 years together. The band's album *White on Blonde* (1997) rode the "Britpop" wave to become a massive international sensation and their *Greatest Hits* collection has sold more than 15 million copies.

❏

Chris admires this example of Tommy's work: "Any cartoonist will tell you the hardest people in the world to draw are pretty girls, and they don't come much prettier than Sharleen. It's even harder to caricature them, but Tommy has managed to make it look easy."

Chris Sommerville

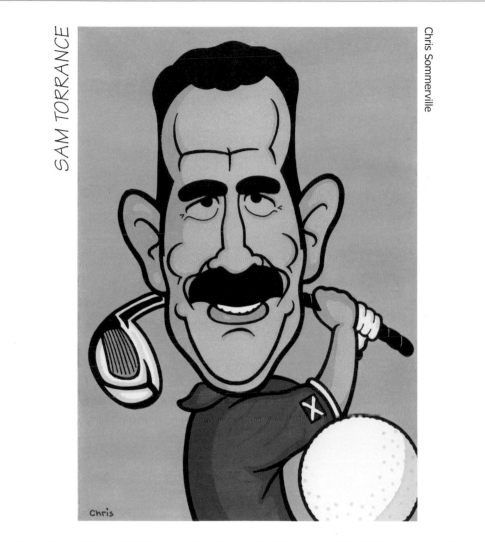

Chris

Golfer Sam Torrance hails from Largs, where he was born in 1953. He turned professional in 1970, and has appeared for Scotland in eleven World Cup matches and nine Alfred Dunhill Cup matches, captaining his country to victory at St Andrews in 1995. Of his numerous Ryder Cup matches, the wins in 1985 as a player, and 2002 as the team captain, were the most memorable.

BILLY CONNOLLY

Derek Gray

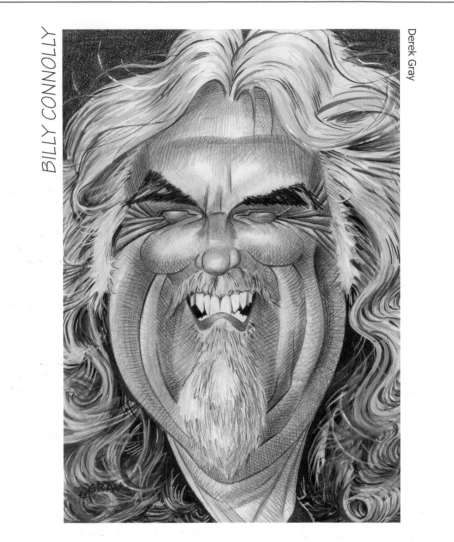

Born in 1942 in Anderston, Glasgow, Billy is a hugely successful stand-up comedian as well as an accomplished actor and banjo-playing folk singer. One of the city's most famous sons, he performs to sell-out crowds around the world. Affectionately known as "The Big Yin", he recently announced his return to Scotland on a permanent basis after spending many years split between a home in California and a substantial lairdship in the Highlands.

❑

Derek: "The problem in caricaturing certain subjects—particularly performers—is which 'look' to focus on. Connolly has had lots of facial hair, no facial hair, coloured facial hair, and everything in-between. He has also been famous for over 30 years, and gone from a skinny 'Banana Boot' wearer to the imposing grey-haired figure of today. I opted for what he calls his 'Winter Plumage'."

ABOUT THE ARTISTS

The Scottish Cartoon Art Studio is the brainchild of young entrepreneur Chris Sommerville, who in 1999 and with support from The Prince's Trust and the East End Partnership, opened the first and only studio in the country that makes the skills of cartoonists available to the public and corporate sectors alike. Unapologetically proud of cartooning, the Studio's ethos remains to showcase and promote it as both a valid art form, and creative work of real value.

Cartooning is really a catchall term for several different disciplines. The Studio produces character designs, comic strips, editorial cartoons, storyboards and more. However the team have, from the outset, specialised in caricature, be it live caricature (quick likenesses produced from sittings) or presentation caricature (fully-rendered pieces where the artist uses photographs of the subject). Among some of the luminaries who own SCA Studio caricatures are: film director Terry Gilliam; Matt Groening, creator of *The Simpsons*; and HRH The Prince of Wales.

The Studio artists have had their work exhibited and published in Croatia, Norway, France, Romania, the UK and the USA. *Fizzers* is their first book and features work shown at the Scottish National Portrait Gallery April-July 2006.

CHRIS SOMMERVILLE, once described in the press as a "cartoon fanatic", has steered the SCA Studio with a steady hand for seven years. Chris is 28 and lives in the east of Glasgow.

TERRY ANDERSON is an ex-student of the world-famous Joe Kubert School of Cartoon & Graphic Art in New Jersey. He is 29 and lives with this wife in north Glasgow.

BRIAN FLYNN left Cardonald College with an HNC in Graphic Art. Brian is 34, married and lives in Paisley.

DEREK GRAY graduated from Gray's School of Art with an honours degree in Fine Art and Print-making. Derek is 38, married, has two daughters and lives in Milton-of-Campsie.

TOMMY SOMMERVILLE is happy to be called a lesser-known artist, but has always "banged the drum" for the cartoon art form. He is 52 and lives with his wife in the east of Glasgow.

EDD TRAVERS left Glasgow's College of Building and Printing with an SNC in Art and Design, an HNC in Graphic Design and an HND in Illustration. Edd is 32, married and lives in Kirkintilloch.